YOU HAVE SEEN THEIR FACES

YOU HAVE SEEN THEIR FACES

By Erskine Caldwell and Margaret Bourke-White

An Arno Press Book
Published in Cooperation with
DERBIBOOKS INC.
1975

Copyright © 1975 by Erskine Caldwell
Copyright © 1937 by Erskine Caldwell and Margaret Bourke-White
This edition published by permission of Erskine Caldwell

Library of Congress Cataloging in Publication Data

Caldwell, Erskine, 1903-
 You have seen their faces.

Reprint of the 1937 ed. published by The
Viking Press.
 1. Farm tenancy—Economic aspects—Southern
States. 2. Share-cropping. 3. Cotton
growing—Southern States. 4. Southern States—
Social conditions. I. Bourke-White, Margaret,
1906-1971, ill. II. Title. III. Series.
HD1511.U5C32 1975 975'.04 74-30622
ISBN 0-405-06769-0

Manufactured in the United States of America by Arno Press Inc.

TO PATRICIA

E. C.
M. B.-W.

No person, place, or episode in this book is fictitious, but names and places have been changed to avoid unnecessary individualization; for it is not the authors' intention to criticize any individuals who are part of the system depicted. The legends under the pictures are intended to express the authors' own conceptions of the sentiments of the individuals portrayed; they do not pretend to reproduce the actual sentiments of these persons.

INTRODUCTION

The tortured face of poverty was not an appealing sight in the Deep South in the 1930's when You Have Seen Their Faces *was first published. Now, forty years later in the 1970's, whether in full view or in profile, the shriveled visage has not been improved by the passing of time. And this was during a period when numerous social and economic benefits were being freely bestowed elsewhere in American life.*

Even though the unforgettable image itself remains, otherwise all is not the same. One of several noticeable changes to come about during this significant era in the South has been the exodus of disadvantaged people who have departed from public view after having been relegated to the realm of the unwanted and disinherited.

Some of the impoverished families, displaced by modern agricultural machinery and lacking physical or mental qualifications for factory jobs, retreat in defeat to hiding places in the rural slums of the hinterland. Other families, similar victims of advanced technology and helpless in their social and economic distress, are driven by necessity to crowd into crime-breeding urban slums and there become lifetime prisoners of their own existence.

Whether in a narrow ravine of a coal town in Appalachia or on the back side of a cotton farm in Arkansas, many of both the young and the old in these disadvantaged families are handicapped by physical deformity, untended disease, or, as more prevalent, lack of minimal nutrition.

As it would be in any part of the world, this is a devastating condition of human life. And in the Southern States, rural or urban, white and black alike, the population for many generations has been afflicted to this day by the seven devils of poverty. Moreover, this has been a common occurrence even though decades of good times have produced widespread industrial prosperity accompanied by unprecedented educational advantages and democratic rights and privileges.

And now, as time goes on decade by decade, an effective cure for persistent and unyielding poverty in the Deep South is not likely to be found until first of all the cause of it can be discovered. Many and varied have been the learned theories propounded and eloquently argued in the past among lawmakers and welfare organizers, yet the uncounted islands of hungry and deprived people continue to exist in spite of all reason and effort.

Though past generations have failed to find the source of human poverty and banish it from the earth, generations to come could well be so enlightened and concerned that they will undertake a diligent and eventually successful search for its elusive origin.

Meanwhile, **You Have Seen Their Faces** *may serve as a reminder that poverty and its many attendant ills are still close to home — and holding.*

ERSKINE CALDWELL
November, 1974

YOU HAVE SEEN THEIR FACES

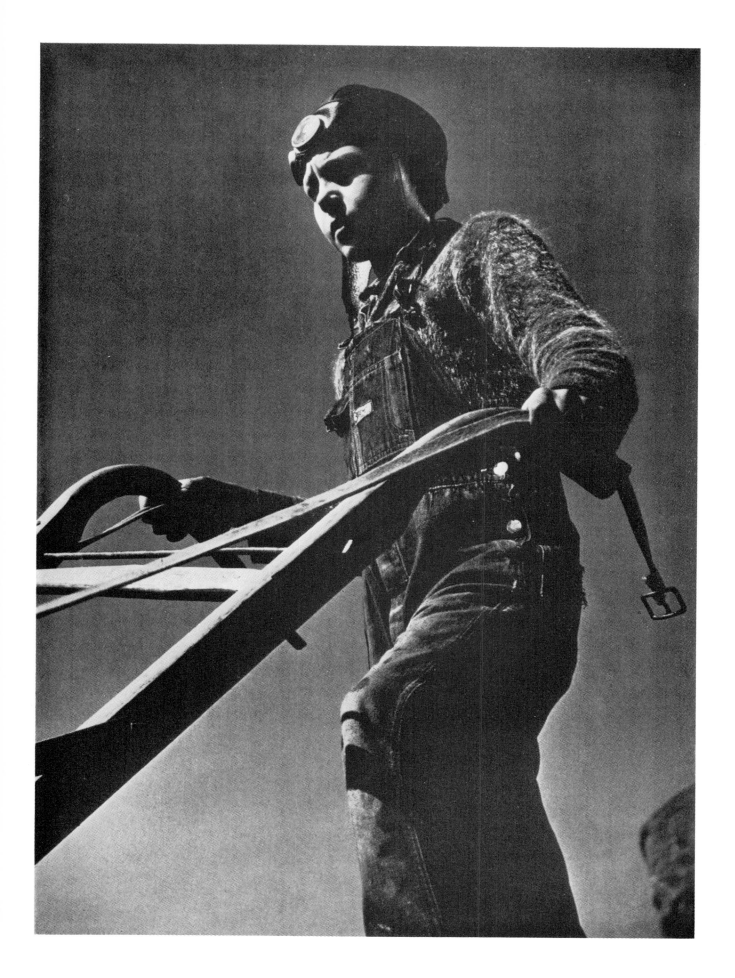

Elbow Creek, Arkansas

"My father doesn't hire any field hands, or sharecroppers. He makes a lot of cotton, about sixty
bales a year. Me and my brother stay home from school to work for him."

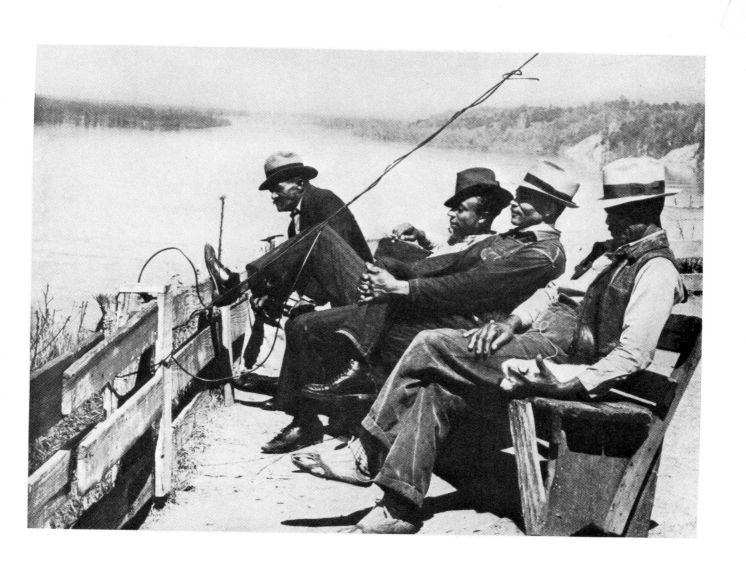

Natchez, Mississippi
"Just sitting in the sun watching the Mississippi go by."

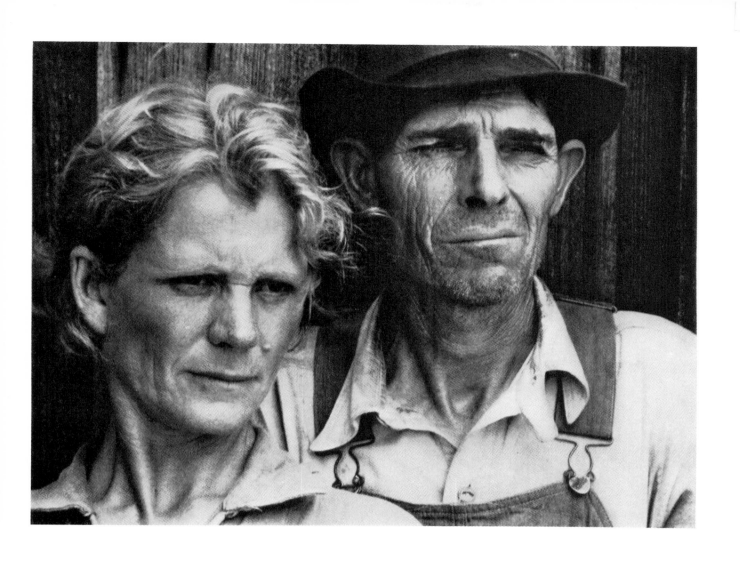

Maiden Lane, Georgia
"A man learns not to expect much after he's farmed cotton most of his life."

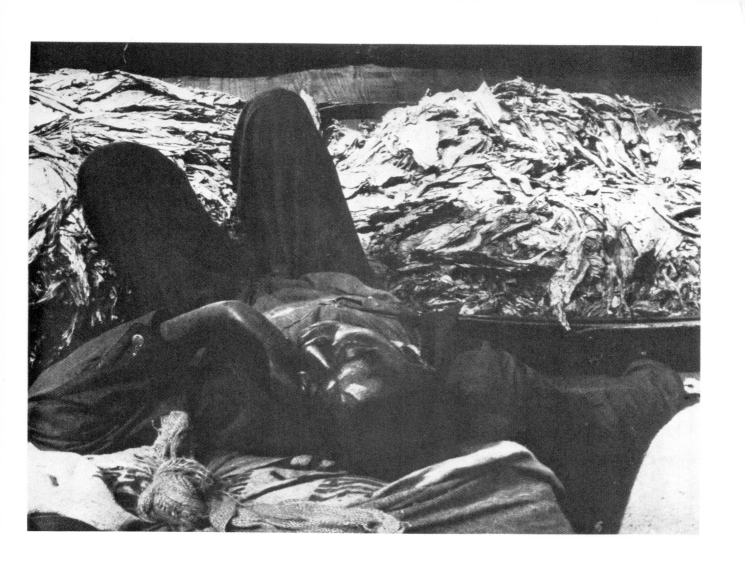

Statesboro, Georgia

"The auction-boss talks so fast a colored man can't hardly ever tell how much his tobacco crop sells for."

Summerside, Georgia
"My daddy grows me all the watermelons I can eat."

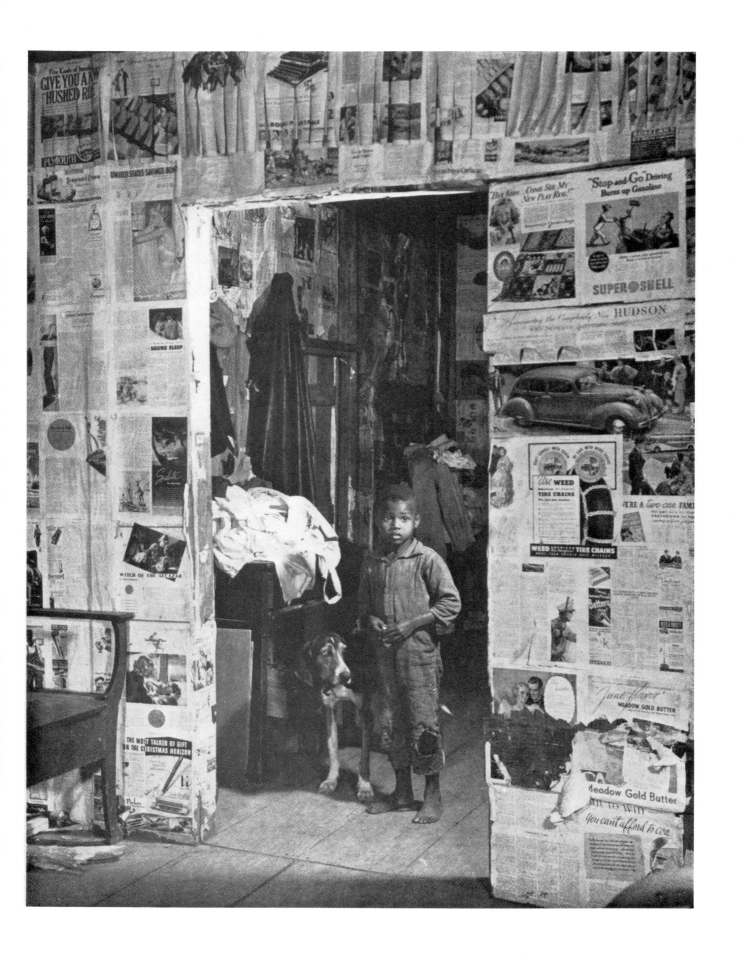

East Feliciana Parish, Louisiana
"Blackie ain't good for nothing, he's just an old hound dog."

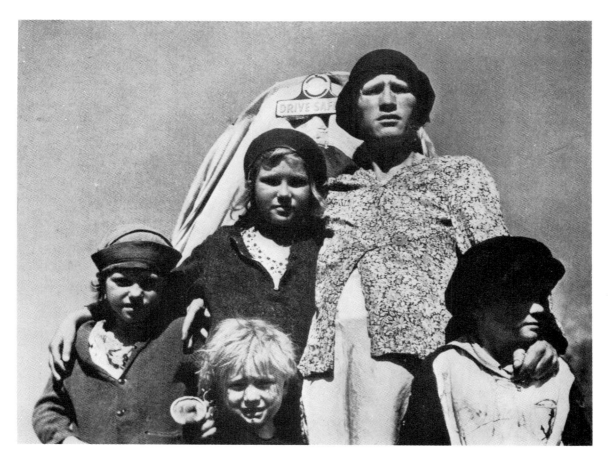

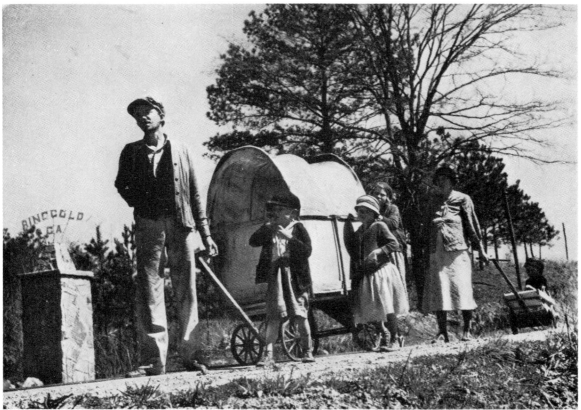

Ringgold, Georgia

"Those poor people walking all the way from Florida looking for a job, and hungry every step. It's a shame they have to walk so far, but they've got to go somewhere—they can't stay here."

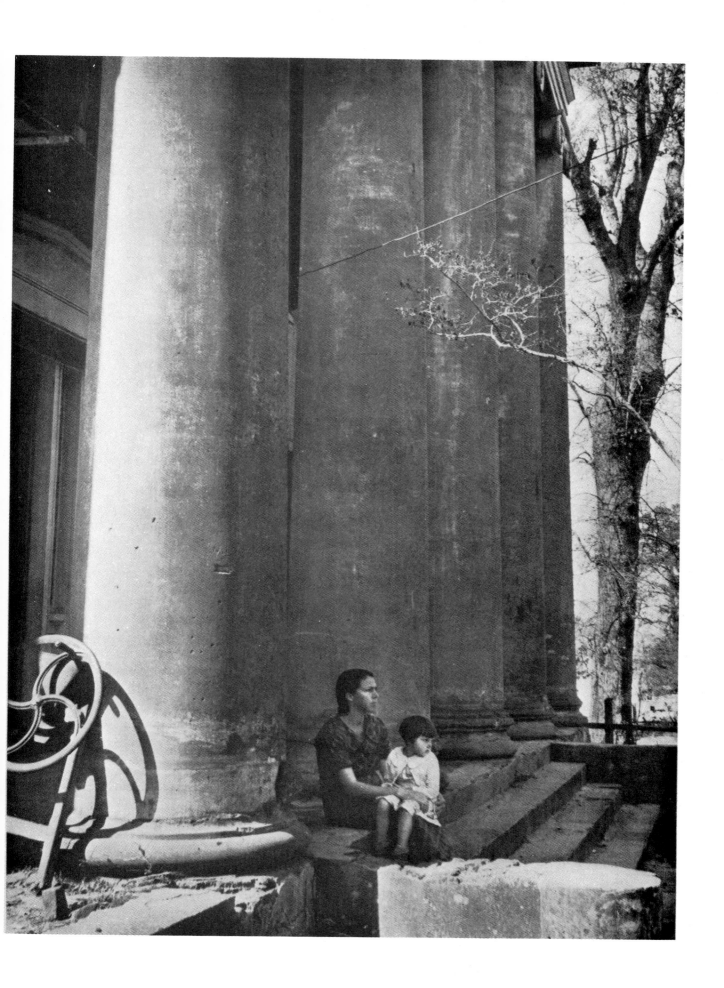

Clinton, Louisiana

"I don't know what ever happened to the family that built this house before the War. A lot of families live here now. My husband and me moved in and get two rooms for five dollars a month."

I

THE SOUTH has always been shoved around like a country cousin. It buys mill-ends and wears hand-me-downs. It sits at second-table and is fed short-rations. It is the place where the ordinary will do, where the makeshift is good enough. It is that dogtown on the other side of the railroad tracks that smells so badly every time the wind changes. It is the Southern Extremity of America, the Empire of the Sun, the Cotton States; it is the Deep South, Down South; it is The South.

Twice a year it takes life easy, lolling in the shade when the sun begins to blister, huddling around the stove when the cold winds begin to blow. The rest of the time it works harder than anybody else, chopping its cotton and sawing its wood from dawn to dusk. In return for its labor it does not expect much, does not ask much, never receives much. It has pockets in its pants, but there are holes in the pockets. When it is paid

in nickels and dimes, the money dribbles along the wayside before the day is over; when it is paid with a dollar bill, the money is stowed away in the toe of the shoe, and kept there until Saturday.

This is the place where anybody may come without an invitation and, before the day is over, be made to feel like one of the home-folks. Scientists with microscopes and theologians with Bibles come to the South to tell it what is wrong with it, and stay to buy a home and raise a family. Gaping tourists come to pick its flesh to pieces, and remain to eat fried chicken and watermelon for the rest of their lives.

Mark against the South its failure to preserve its own culture and its refusal to accept the culture of the East and West. Mark against it the refusal to assimilate the blood of an alien race of another color or to tolerate its presence. Mark against it most of, if not all, the ills of a retarded and thwarted civilization.

The South has been taking a beating for a long time, and the pain and indignity of it is beginning to tell. It can be seen any day now in the lean and hungry faces of men. It means unrest.

The troubles of this part of America have been laid first to this cause, then to that cause, and finally to the entire list of civilization's plagues and afflictions. Slavery, climate, and hookworm have been favorite causes for generations of finger-pointing pulpiteers and pamphleteers. High-tariff and free-silver advocates had their opportunity to pin something on somebody somewhere, but when they had had their day, the South was still sick. Blaming it all on the failure to build the Nicaraguan Canal was for a time a serious-minded occupation. The coming of the boll-weevil, the army-worm, and the screw-worm brought forth a new generation of bush-beaters and stump-thumpers who were certain they held the secret of the South's troubles in the palms of their hands. After all these years the sun still rises in the East and sets in the West and the South is still sick.

Whatever the cause of the South's despair may prove to be, it be-

comes more evident as each day passes that it is now a worn-out agricultural empire.

There was a time when heads were put together in an effort to devise ways and means of making two blades of grass grow where only one had grown before. Now heads are being beaten against the ground in a desperate struggle to keep the one blade alive. Hopes of having two bales of cotton in place of one, of having two dollars instead of one dollar, have given way to hopes of being able to make half a bale of cotton, to make fifty cents.

The soil has been depleted and eroded. This was not a rich soil to begin with. It was nothing at all like the alluvial earth of rich valleys elsewhere, it was not like the glacial deposits of fertile loam in other sections of the nation. In the South the top-soil was formed by the decomposition of grasses, leaves, and wood. The depth of top-soil varies. In one area of a State it might be one inch deep, in another twelve inches. The thin soil was the first to become exhausted of its fertility. It now lies barren and worthless after decades of cotton-growing. As each new year arrives, more acres are added to the total. In time, pine seedlings will be planted or will spring up and take root and begin the long process of revitalizing the soil. But in the meantime the rains and winds are eroding the land, washing away and blowing away the earth, until it takes on the appearance of a country cut and scarred by deep gullies and gorges.

The Mississippi Valley Delta and the Black Belt of Alabama are two sections of the South that still produce cotton in abundance. It grows, matures, and yields without fertilizer and without effort. The soil there will be deep, fertile, and productive for a long time to come. Elsewhere the sub-soil, both sand and clay, is being plowed up to be mixed with the little top-soil that remains in an effort to make plants grow. There is no fertility in sub-soil, but when brought to the surface it gives the appearance of fertility and, when mixed with fertilizer, will produce

enough cotton, providing that the rains and sun are not extreme, to pay for the fertilizer in normal times. Farming in sand or clay is a back-breaking, spirit-crushing existence.

There are reasons for this impoverishment of the soil that go deep into the economic life of the South. The successful cotton-raisers have always been plantation-owners. The plantations were large, generally from five hundred to five thousand acres of land in size. The owners for the most part had one main concern, and that was to make as much money as they could as quickly as they could.

Nothing made money like cotton. Nothing else grew like cotton. Cotton was king.

Now the day of the plantation is over, except in the Delta country and in the Black Belt, and cotton is not king any longer.

The plantation system pauperized the soil to such a great degree that raising cotton became a means of making a living rather than a method of making a fortune. The plantation-owner, when he became aware of what had happened to the soil, withdrew to the nearest city to live the remainder of his life on his accumulated wealth.

What he left behind was eroded, depleted, unprofitable land. His tenants still had to work for a living, even if he did not, and out of their desperation grew a new system. The owner became an absentee-landlord. The plantation was divided into one-man farms and rented to the tenants. The rent was paid either in half of the cotton produced or in an agreed upon number of bales, or on a basis combining the two methods. The plantation system was traded for the sharecropping system, and the South to its sorrow was the victim of the deal.

Before he knew it, the landlord had a new source of income that was larger than his previous one had been. And, besides, in the old days he had had to take his own chances with his crop of cotton, losing money when it rained too much or too little, dipping into profits from preceding years when expenditures were larger than income. In the new era he

had a source of income and profit that was as certain and secure as the seasons themselves.

Rent was paid to him for the use of the land on a sharing basis, and he saw to it that the tenant raised a maximum number of bales. When a hundred tenants produced six bales each, the landlord received three hundred bales, the individual tenant three bales. Cotton was not king any longer, but the institution of sharecropping was making a few men richer than kings, and much better enthroned. They did not have to concern themselves about the welfare of their subjects.

The tenant who set out to farm his portion of the plantation discovered that the land required fertilizer. Without fertilizer he could not grow enough cotton to provide himself with a living, and to pay rent. The rent came first. The landlord generally saw to it that the tenant paid his three or four bales for rent before the sharing began. If there was nothing left to share after the rent had been paid, there was nothing the tenant could do about it. He could only look forward to the coming year, hoping he would be able to make more than the minimum number of bales the rent required. If the following year was a good one for him, he paid off the chattel mortgage he had given in payment for fertilizer he had bought in an effort to produce the rent-cotton.

It is difficult to find a good word to say about such an agricultural system. The sharecropping system was born of the plantation system, and the new was anything but an improvement over the old. The old produced numerous families of wealth who developed a culture that was questionable. The new has concentrated wealth in the hands of a few families who are determined that no culture shall exist.

Much can be said about the detrimental effects of such an agricultural system, more especially when there are ten million persons now living under its yoke. They live in this cotton country on tenant farms which, in many cases, are little more than sand dunes and clay stacks. They are either already worn out physically and spiritually, or are in the act of

wearing themselves out. They are grouped in families of man and wife and from one to sixteen children. They are farming, for the most part, soil that has been yielding diminishing returns for fifty and a hundred years. No matter if they get up an hour earlier to work by lantern light, no matter if half a dozen more children are begotten to supply additional hands in the field, they will continue to fall steadily behind as long as they live on land that produces less and less each time a new crop of cotton is planted.

This is nothing new. It is not a situation that has suddenly come about overnight. But it is a circumstance that becomes more acute day by day as the exhaustion and erosion of cotton land progresses. Fertilizer will increase the yield of cotton, but fertilizer costs money and requires credit that the tenant farmer does not have. A larger farm will produce more cotton, but there is a physical limit to the number of acres a man and his family can cultivate.

The sharecropping system has in recent years branched out into several forms, none of them any more economically sound than the source from which they sprang, and most of them working greater hardships on human lives than the plantation system ever did. Sharecropping has deprived millions of persons of what the rest of America considers the necessities of life.

It deprives children of adequate education because many of them have to work either part of the school year or all of it on their fathers' farms so that enough cotton can be raised to pay rent and buy fertilizer and to get food and clothing. It forces families to live in buildings that are detrimental to health, and it forces them to exist on food that is insufficient. Worse still, it continues in operation year after year, wringing dry the bodies and souls of men, women, and children; dragging down to its own level from higher economic planes new numbers to take the places of those crushed and thrown aside; breeding families of eight, ten, twelve, fourteen, sixteen, and more, in order to furnish an ever-

increasing number of persons necessary to supply the rent-cotton for the landlord.

It is foolish to ask a tenant farmer why he remains where he is. He does move from farm to farm from time to time, but only rarely can he improve his status. Such a question is usually asked with the purpose of covering up an inability to suggest what the farmer could do to lift himself from the hole he stands in. There is cotton to be raised, and he has trained himself to raise it. That is his specialty. It is his life and, if sharecropping continues as an institution, it will become his death.

The tenant farmer in the South is trying to hold onto a spinning world until by some means he is enabled to get a grip on a better way of life. He knows he cannot buy land of his own from the profits of sharecropping. He knows just as well that he cannot save until he earns, and that he cannot earn much more than a bare living from sterile, barren land. He does well, under the circumstances, to hold on at all.

Now that his condition has sunk to depths that stop just short of peonage, there has appeared the first sign of hope. What there is in store for him in the future remains to be seen, but now for the first time there is hope. There has been talk, from one end of the South to the other, of joining with other tenant farmers to take collective action against the institution of sharecropping. The day when it was a sacred bull has passed. The sign of its passing was when the landlords began putting into force other forms of farm tenancy. Farms were leased to tenants, but sharing of the cotton continued; tenants were paid to work by the day, but their pay was received in a share of the cotton. No one was fooled, least of all tenant farmers themselves.

The farmer has little, if anything, to show for his years of labor in the past. But the hardships he has experienced will stand him in good stead when the time comes for him to begin thinking about taking over the job of raising cotton—the job in which the landlord failed to treat him fairly and squarely.

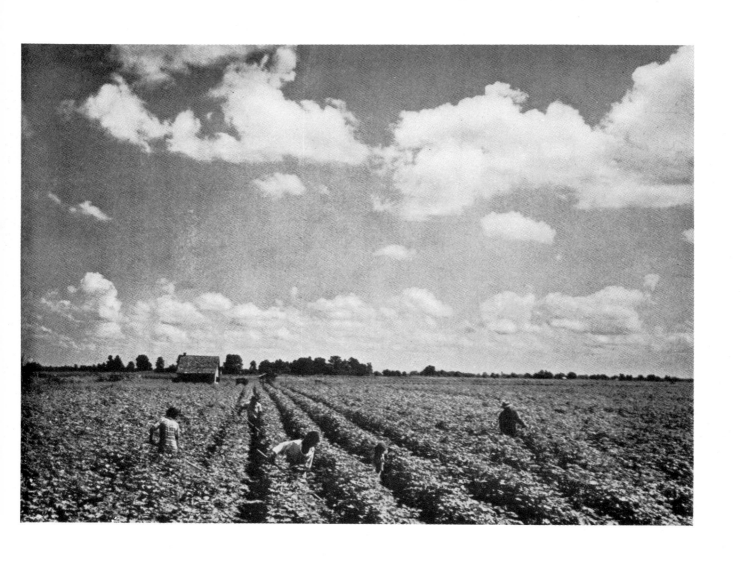

Lake Providence, Louisiana
"Bringing the white-boss's fine cotton along."

Fairhope, Louisiana

"Folks here wouldn't give a dime a dozen for white tenants. They can get twice as much work out of the blacks. But they need to be trained. Beat a dog and he'll obey you. They say it's the same way with the blacks."

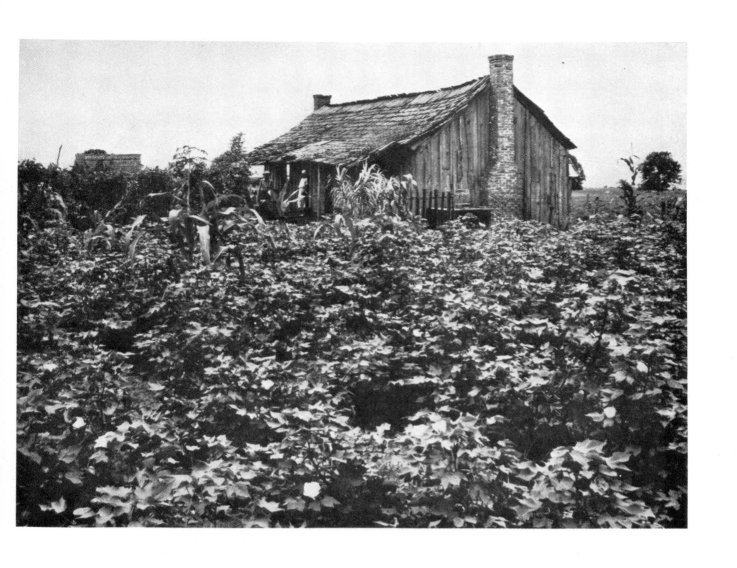

Marion Junction, Alabama

"No place to plant me a little garden when the white-boss says to plow the cotton in right up to my front door."

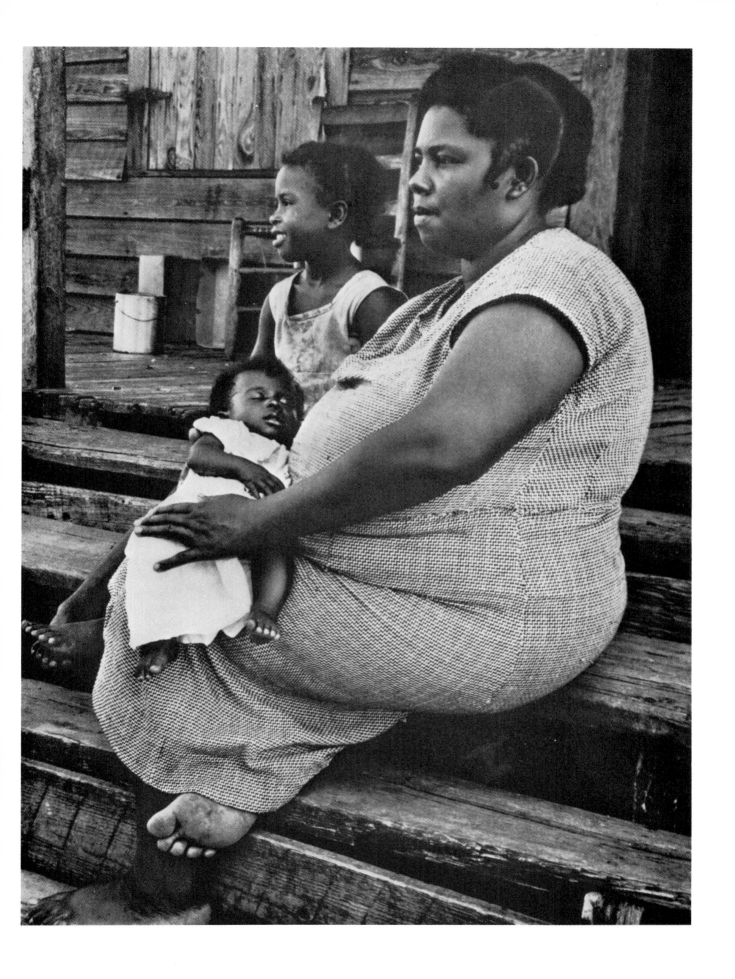

Ocelot, Georgia

"I got more children now than I know what to do with, but they keep coming along like watermelons in the summertime."

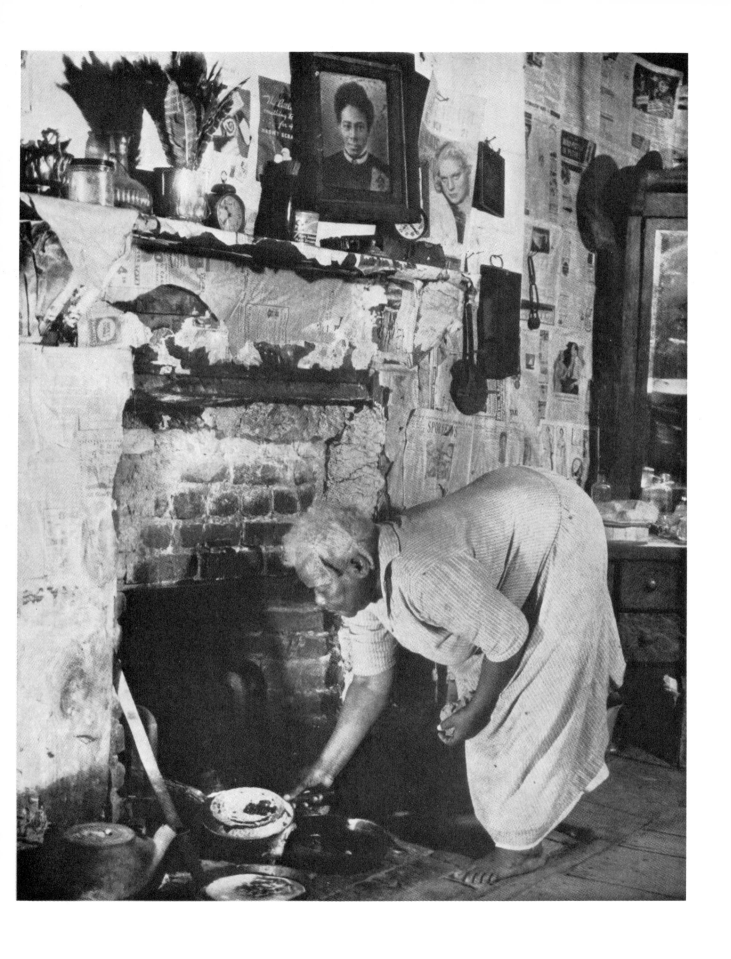

Pee Dee, South Carolina

"What my menfolks have a powerful gnawing for right now is a slab of sow-belly to eat with this cornbread."

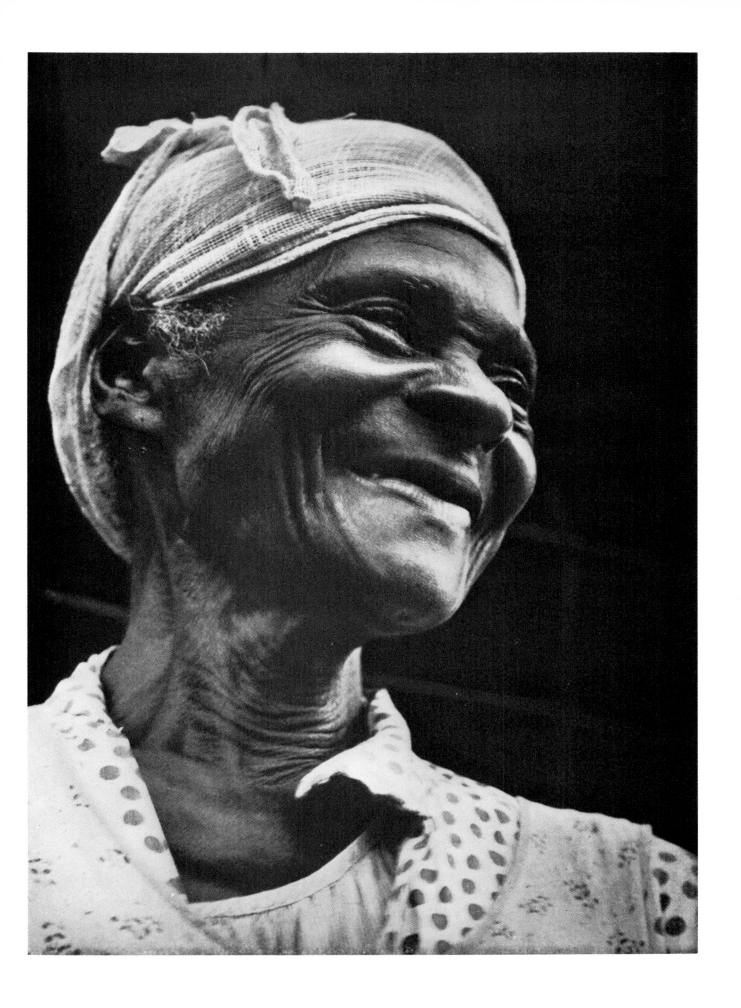

Atoka, Tennessee

"I reckon I forgot to remember how old I is."

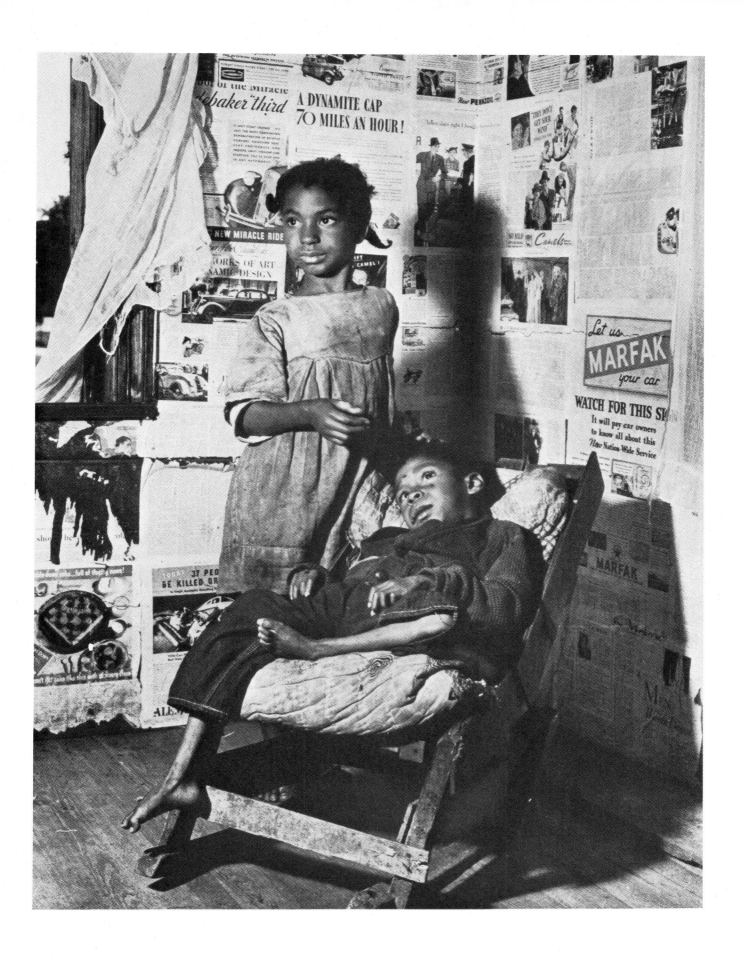

Belmont, Florida
"Little brother began shriveling up eleven years ago."

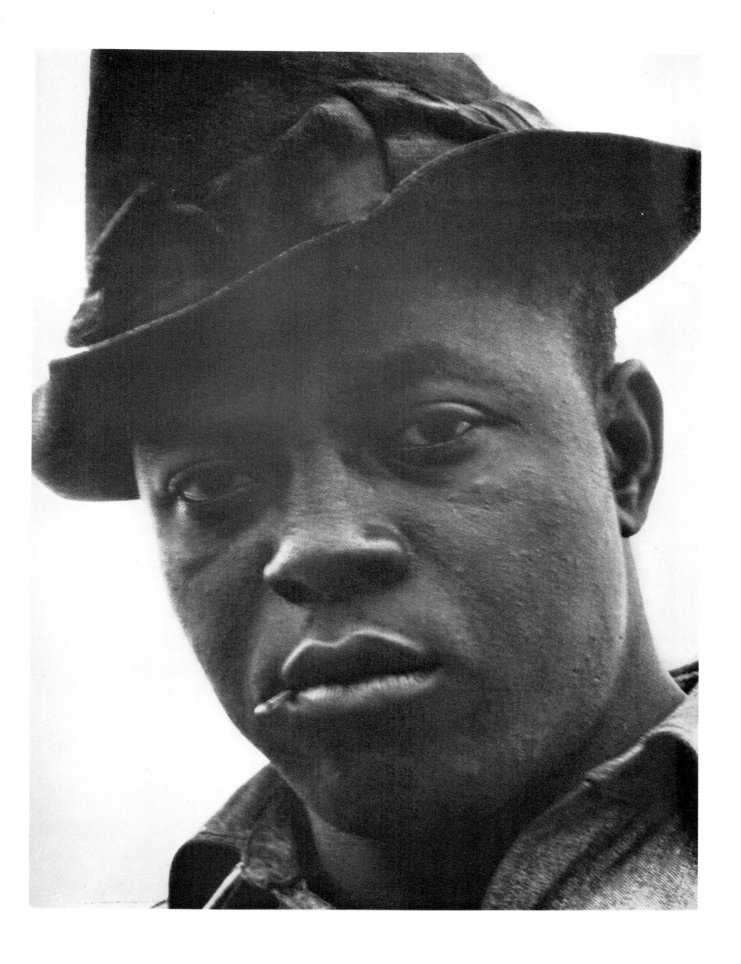

Porter, Arkansas

"We got seventy-five cents a day in the cottonfield last year, and a whipping if we didn't stay and work. I hear them say we'll get a dollar a day this year."

II

Government and God put together in a lifetime couldn't beat a pinch of sense into those fool cotton farmers. They think all they've got to do is go out there and get hold of forty acres of land, plant cotton, and look at the pictures on hundred-dollar bills. Most of them don't even try to raise feed for their mules, and then they have to come into town and try to wrangle corn and hay on credit. They act like they think that sets them up to look like farmers, but all they're doing is carrying on like a mouse in a bucket. They think if they touch anything but cotton they'll be doing something beneath their dignity. When I was out there twelve years ago trying to make a living raising cotton, I didn't act with any more sense than the farmers do now. It seemed like cotton went to my head just like a drink of raw whisky. I thought I was somebody. I'd come to town and tell everybody how to raise cotton, how to run a farm, how to educate children, how to treat a woman, how to keep the blacks in their place, and how the government ought to be run. All that time I'd have amounted to something if I'd tended to business and tried to do what a farmer ought to but don't have the sense to do. I thought it was beneath my dignity to plant a garden and raise feed for the stock. The first thing I knew, I didn't have an inch of land left, and I was so puffed up being a cotton farmer I didn't have the sense to know I was drunk on cotton. That's the worst thing cotton does to a man. It makes him think he's sitting on top of the world, and the first thing he knows he's spending more on food for himself and feed for his stock than cotton brings in. Store-keeping is no high-minded calling, but it teaches you what a fool cotton can make of a man.

CLINTON, LOUISIANA

There are no landlords striding over their Mississippi Delta plantations cracking ten-foot braided-leather whips at their Negro sharecroppers' heels. At least there are only a few. Peonage, like lynching, is not condoned in theory; but conditions, usually best described as local, are sometimes called upon to justify it in practice. And when a plantation-owner feels the urge to beat and whip and maul a Negro, there are generally several within sight or sound to choose from. Keeping a Negro constantly in physical bondage would be an unnecessary expense and chore; the threat of physical violence is enough. In the first place, the Negroes on Mississippi Delta plantations were bred with the fear of God in their souls; and in the second place, they know by rote the white man's laws after all these years of subjection and intimidation.

The colored man's lord and master has had the situation well in hand for many years.

The landlord, as likely as not, spends his summers at Biloxi on the Gulf of Mexico, sail-boating, fishing, and watching the stock market. The plantation-manager sits in the company office from nine to five, dictating, purchasing, selling, scanning government crop reports, studying New Orleans cotton futures. The overseer sits in his office making out his reports on how many acres of cotton were chopped the day before, how many men and women and children were at work and how many were not at work, how many points of rain fell during the preceding twenty-four hours, and the amount of deficiency or excess of moisture to date. The riders on horseback view the work in progress, cautioning this man to keep his shadow moving, cautioning that woman not to leave any grass growing in the cotton, cautioning the child to keep his row abreast of his mother's row.

The successful plantation-owner, whether in the Delta or in the Alabama Black Belt, has an organization that operates as efficiently as that of a money-making steel-producer, or oil-refiner, or automobile-manufacturer. He acquires tenants just as any other manufacturer would

buy raw materials, and processes tenants into cotton, cotton into dollars.

The Negro tenant is a solitary figure in the plantation country. It is not an accident that he stands there isolated from the white tenant, out of contact with white workers who once labored with him in the fields.

The Delta and Black Belt landowner has been systematically eliminating the white tenant from his plantations for a number of years. The white tenant was given to understand that he was no longer wanted. Next, if he did not take the hint, he was told to leave. Finally, if he persisted in remaining where he was, he was driven off the land. As soon as he was out of the way, his place was filled by a black tenant. The white tenant farmer was forced to gather up his family and make his way into the eroded and depleted hill country. The landowner in the rich plantation country wants a man who can be subjected to his will by means of fear and intimidation.

The Negro tenant farmer is the descendant of the slave. For generations he has lived in mortal fear of the white boss in the cotton country. He has seen his women violated and his children humiliated. He himself has been discriminated against, cheated, whipped, and held forcibly in an inferior position. Every white face he sees is a reminder of his brother's mutilation, burning, and death at the stake. He has no recourse at law, because he is denied the right of trial before his peers. The Negro tenant farmer on a plantation is still a slave.

Arnold Berry is a Negro tenant farmer on a plantation in Eastern Arkansas in the Delta country. He is twenty years old, single, and lives with his grandmother, who is fifty-five years old. They live, rent free, in a tenant house of three rooms on the Teacher Plantation. This plantation, within sight of Mississippi River levees, is near Wilson, Arkansas. The Delta country there is part of the best cotton-producing land in America. The soil is black, well watered. The plantations in that section are large, generally of one to eight thousand acres.

Berry has worked on the Teacher Plantation as both sharecropper

and field hand. When he works as a sharecropper, he averages about a hundred and eighty dollars a year. When he works as a field hand, he receives seventy-five cents a day. Not seventy-five cents every day in the year, but seventy-five cents a day when there is something for him to do. He has averaged a hundred and ninety dollars a year as a field hand. He has never made more than two hundred dollars a year. He has often wondered why, at the end of a year, he has never been able to make more than that.

Like all the tenants on the Teacher Plantation, he is allowed a maximum credit of four dollars and a half a week at the plantation store. At the end of the year, as far back as he can remember, his store bill has always amounted to two hundred and thirty-four dollars, which represented the total of his weekly credit for fifty-two weeks. Sometimes he bought less than four dollars and fifty cents' worth of goods at the store, but always his bill for the year was the same. When he found that out, he made up his mind to use his credit to the limit. He always found himself in debt anyway, according to the books in the plantation office, and whether the debt amounted to thirty-four dollars in a two-hundred-dollar year, forty-four in a hundred-and-ninety year, or fifty-four dollars in a hundred-and-eighty year, it was carried over as debt and entered on his account for the following year. He works off the debt at seventy-five cents a day and, when the cotton crop is unusually good, by deducting for his store account all money due him over and above two hundred dollars. The method of paying off his yearly debt was suggested by the plantation-owner.

The plantation store carries in stock staple groceries and clothing. Berry buys flour, meal, bacon, coffee, lard, and candy; he also buys overalls, shirts, and shoes, and his grandmother buys calico, buttons, and shoes. He can buy anything in stock that he wishes, up to four dollars and fifty cents' worth a week. He could get cash if he asked for it, but the plantation store is the only one near by, and if he walked to the next

store, it would be a store owned by another landlord, and then he would be called upon to explain why he earned his living on one plantation and spent his money at another.

When Berry is sick, his weekly credit is reduced to three dollars and a half a week for as long as he is unable to work. The plantation pays the doctor's bill and the medicine bill, and they in turn are entered on the account books to be deducted from his credit when settlement day comes at the end of the year.

There has been talk of the daily wage being raised from seventy-five cents to one dollar. When Berry heard about it, his first thought was that he would be able to get out of debt. He did not wish to marry, or go to Memphis, or buy an automobile. He wished to be able to stop cotton farming and to sell household supplies, such as soap, to tenants on the plantations in the Delta. If that turned out to be successful, he wished to save enough money to buy some cotton land of his own, not a plantation, but ten or fifteen acres. He had given up hope of ever getting ahead by working on the plantation.

Berry considers himself fortunate. He does not own anything, except the clothes on his back, and a change of them in his house; he cannot move from the plantation without getting permission from the landlord; if his grandmother should die, he would have to marry and produce children, since it is a custom on the plantation that each tenant supply one or more additional hands for the fields.

He considers himself fortunate, nevertheless. Most important of all, to him, is the fact that he is a tenant on the Teacher Plantation instead of being a tenant on the Harris Plantation. The Harris Plantation adjoins the Teacher.

The Harris Plantation is one of the largest, most prosperous, and most notorious in the Delta. Berry has friends who are tenants there, and who wish they were somewhere else. He has seen things take place there that he is afraid to talk about, and after seeing one of his friends whipped by

a rider, he was more determined than ever to get out of debt and into house-to-house salesmanship.

The policy of the Harris Plantation is to pay tenants for their labor and their cotton in coupons instead of in money. The coupons can be used only in the plantation store. The white sharecroppers and wage hands protested against the coupons, and asked for payment in money. Thereupon a systematic exclusion of white tenants was instituted. The plantation offered to buy, at approximately fifty cents on the dollar, the white tenants' crops. If the offer was accepted, the white tenant took the money and moved off the plantation; if it was rejected, the white tenant was forcibly evicted and the crops confiscated. When the white tenants had been moved off, Negro sharecroppers were brought to the plantation. They were more easily intimidated, and were afraid to protest against the coupons. Those who did object attempted to leave; the riders caught them, and they were whipped for leaving without permission. They were then told that, if they wished to leave, they could do so by paying the plantation fifty dollars in cash. None of them had fifty dollars, or any part of it. They remained.

The white sharecroppers and wage hands who were forced off the Harris Plantation scattered in all directions in the South. Some found farms in the Delta, some went to the Arkansas hill country, others crossed the Mississippi River and settled on whatever tenant farms they could find.

More than two hundred families, Negro tenant farmers, live on the Harris Plantation. Many of them are well satisfied with their place, thankful for a chance to be able to secure credit at the plantation store every week, even if they will never see or have actual money from one year's end to the next. There are others who would like to leave if they could find a better landlord to work for. Some want to leave, and would move if they were not bound by the plantation's law that no tenant can leave without permission. The custom is that, if a tenant insists on re-

ceiving permission to move, he is charged fifty dollars, which is entered on the books as back debt. He cannot leave until it is paid; if he insists on leaving anyway, and does move, he is subject to arrest. He can be charged with attempting to evade a debt, brought back, and placed in custody of the plantation until the debt is worked out. How long it takes to work out a fifty-dollar debt is a problem no tenant on the plantation has yet been able to figure out. For, while working out the debt, he is at the same time going into debt to the extent of four dollars and fifty cents a week for food and clothing. The tenant's only hope is in finding a benevolent plantation-owner willing to pay the fifty dollars, in cash, for him in return for his agreement to work out the amount.

This may or may not be legal, and, strictly speaking, it may not be peonage, but it is so close to peonage in practice that as far as the sharecroppers are concerned it may just as well be.

Whether life is like this in Arkansas or Louisiana, in Mississippi or Alabama, is of small importance. Plantation life for the sharecropper, no matter where, is difficult. The fact that some plantation-owners conduct their farming operations humanely is not enough to overbalance the defects of the plantation system itself. It is an antiquated method of agricultural production that has no place in a social order where, notably in industry, labor demands and receives compensation for services rendered. Workers at other trades in America may have longer hours, may even receive less pay, but plantation sharecroppers live in bondage.

These are the plantation-bound families that eat cornbread and molasses, that buy a fifty-cent bottle of patent medicine when one of the members is ill because the doctor and his medicine cost three dollars, that have neither newspaper nor magazine in the house, that have no lamp because kerosene costs twelve cents a gallon.

These are the people who have to take off their hats when they meet a white man walking along the road, keep their mouths shut when their children are allowed only four months of school a year or none at all,

[55]

accept without the bat of an eye an oral accounting of their year's labor.

The Negro sharecropper on a Delta plantation who has learned the white man's rules, and who keeps them, is allowed to live a peaceful life. On many of these plantations, if he protests, or even so much as presumes to argue over the number of bales of cotton he has raised, he is a bad nigger, a human being who is hounded and persecuted for the rest of his life.

They'd have to call out the regular United States Army to make me go back to Eastern Arkansas and work on one of those cotton plantations. I'm making good pay bossing a road construction job for a contractor, and I know when I'm well off. Two years ago I was out there living with my sister and her husband in Arkansas and we had a good prospect of clearing twenty bales of cotton, after sharing with the landlord. The crop came along fine all summer, the sun was just right, the rain was just right, and the insects held off just right. We'd been there four years, and it was the best-looking cotton I'd ever seen. After we got it laid by, in late summer, my brother-in-law and me started talking about buying a farm of our own up close to Little Rock. Then the first thing I knew, the landlord came down and said he wanted to buy us out. I told him we'd sell out our crop for what twenty bales would bring. He said ten bales, or nothing. We told him nothing doing. The next day he sent a colored family down to move into our house. We didn't budge an inch. Pretty soon half a dozen of his riders came down and stood us off while the colored family was moved in. Our things were dumped out in the road. I went to town to see the landlord, and he was there waiting for me with a bill for back debts against us for three hundred and some dollars. We hadn't done any buying at the plantation store on credit, but there the bill was, and he had a deputy with a warrant all made out to serve. He said he'd deduct the bill from ten bales of cotton and wouldn't make any more trouble if we'd leave the country. There wasn't anything to do but take what we could get and move our furniture over to Memphis.

EDGEFIELD, SOUTH CAROLINA

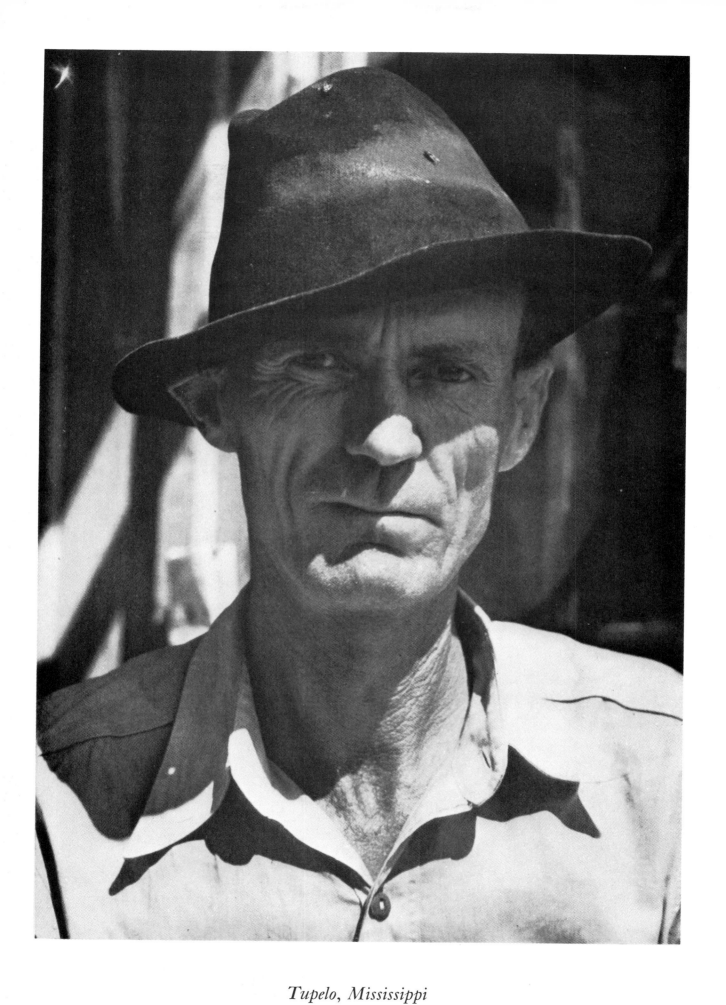

Tupelo, Mississippi
"There were plenty of people who couldn't get a living out of a farm long before the Government heard about it."

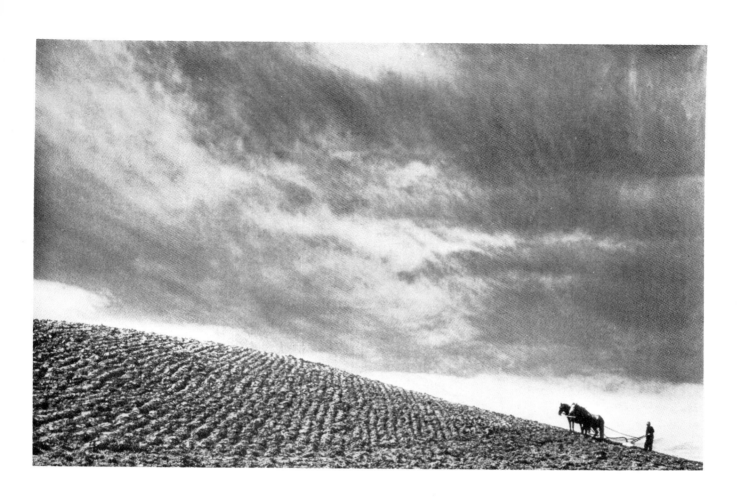

Iron Mountain, Tennessee

"There's lots of things easier to do, and pay more money, but plowing the land and harvesting the crops gives a man something that satisfies him as long as he lives."

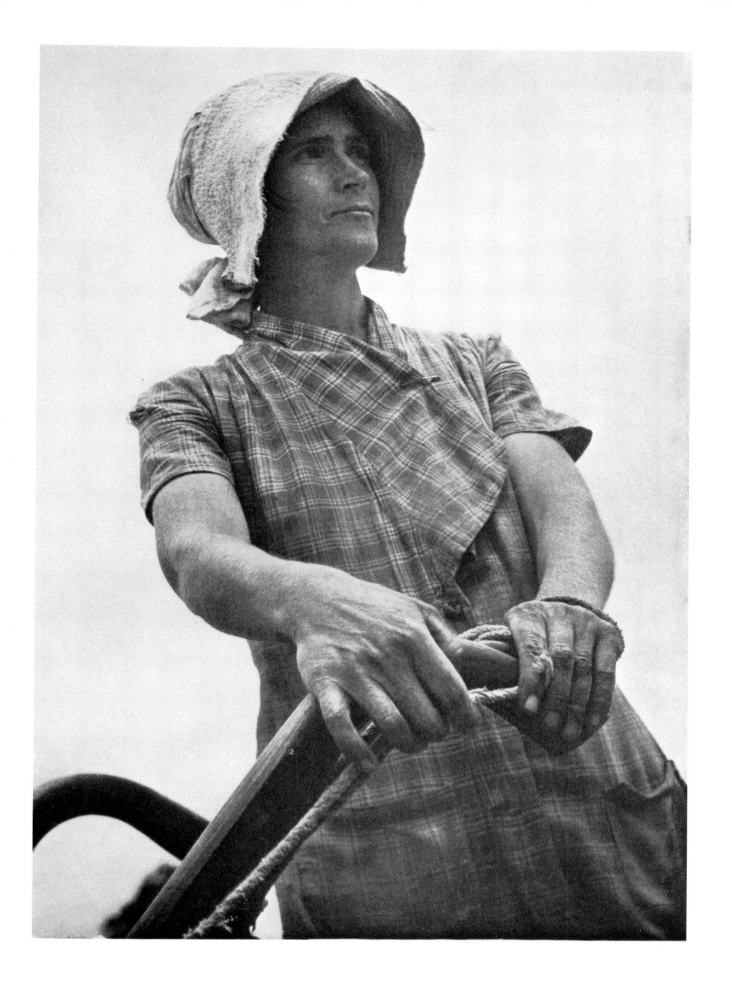

Hamilton, Alabama

"We manage to get along."

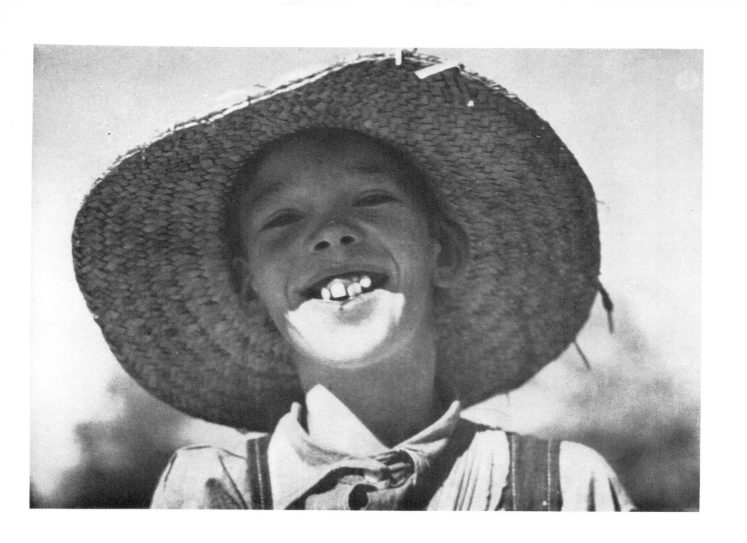

Ozark, Alabama
"School is out for spring plowing, and Pa said I could go fishing."

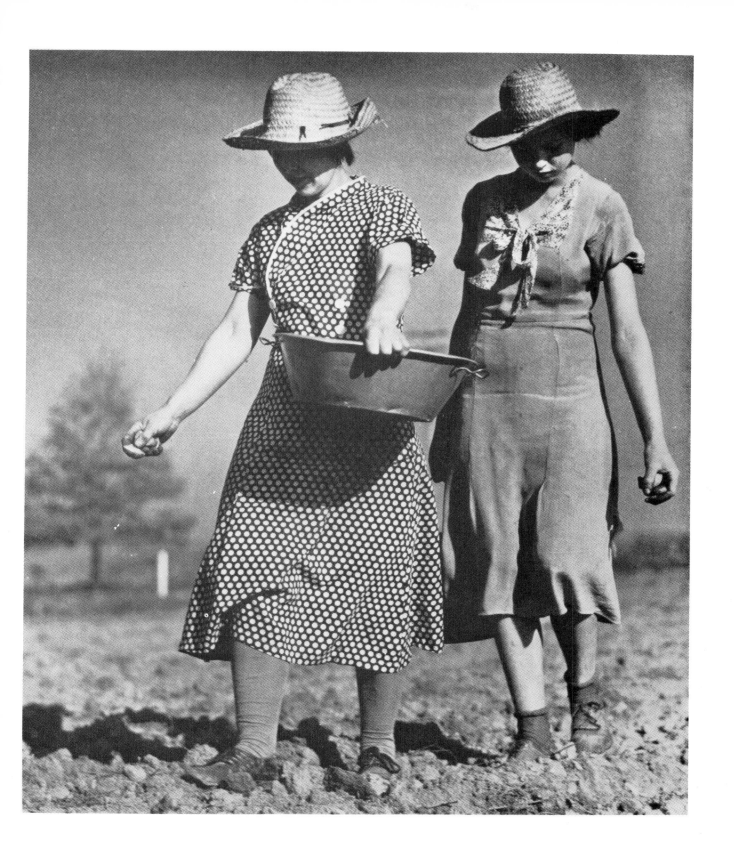

Highlands, Tennessee
"The womenfolks have got to help out just like anybody else."

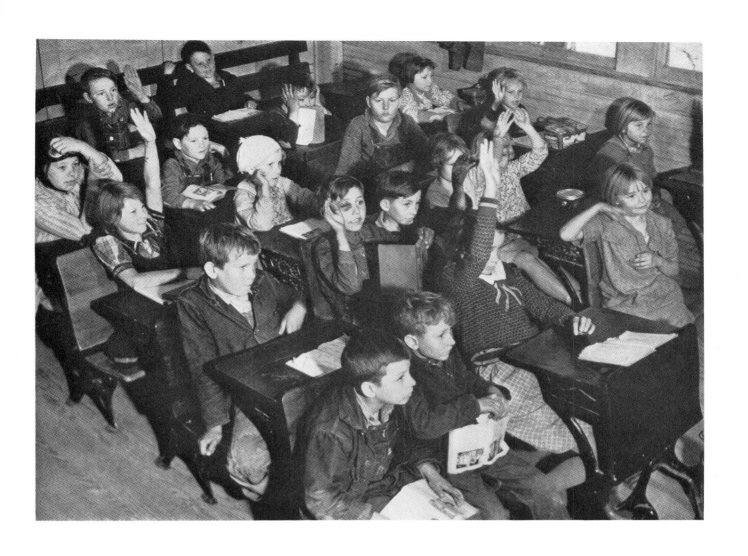

Harrisburg, Arkansas

"Five months of school a year is all I'm in favor of, because I need my children at home to help work the farm."

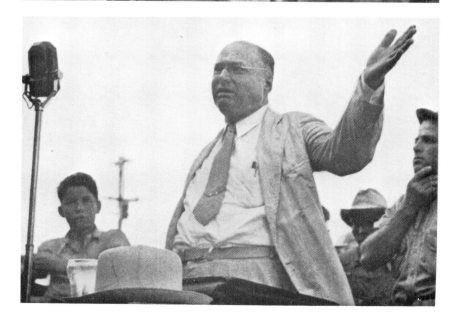

Caxton, Mississippi
"My friends and constituents . . ."

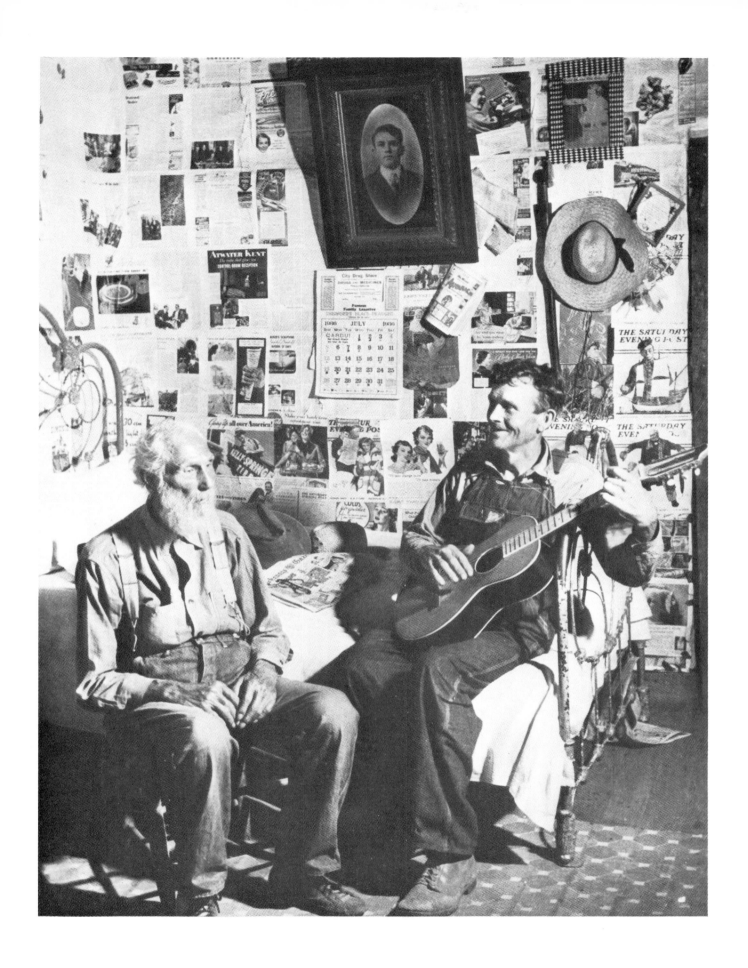

Marshall, Arkansas
"It never felt much like Sunday to me until I plucked the guitar some."

III

If outsiders would stop sticking their noses into other people's business, we'd get along all right down here. We know how to run this part of the country, and we're going to see that it's run like we want it. Every time a nigger kills a white man or rapes a white woman, they say we're railroading him because he is a nigger. We know how to take care of the niggers, because we know them better than anybody else. We live with them all the time, that's why we've come to know them so well. Outsiders think we're hard on niggers just because they're black. Sometimes we are hard on them, but that's because they have to be taught a lesson. The rest of the time we leave them alone. I've been dealing with niggers on my farm for thirty-two years, and I know them a lot better than some jack-leg who comes down here and says I don't treat them right. They get what they deserve, and that's enough for anybody. If I started out tomorrow asking one of my field hands if he would like for me to build him a bungalow with electric lights and a bathroom, by breakfast time the next morning he'd be coming up to the house expecting me to let him sit down at my own table, and by night he'd be wanting to marry one of my daughters. Give a nigger an inch and he'll take a mile. I know them. That's why you have to keep them in their place, and the less you give them, the less they'll try to take from you. Those outsiders who come down here don't know no more about running niggers than I know how to get to the moon. But don't think those know-it-alls don't think they know how. They'll argue your ear off saying the niggers have a right to have this, that, and the other thing, but I just laugh at what they're saying because I know they're making damn fools of themselves. The white people down here are hard on the bad niggers sometimes, but we love the good ones.

MAGEE, MISSISSIPPI

[73]

The Mississippi Valley Delta is the garden spot of the South, but it is a relatively small spot on the map. For every thousand-acre Delta plantation there are a great many tenant farms on the scrawny uplands and eroded hillsides. From the Atlantic to the Ozarks and from the Gulf of Mexico to the Tennessee River, in eleven Southern States, there are thousands and thousands of tenant farmers vainly struggling to squeeze a meager existence from an almost totally impoverished soil. The day will come when there will not be left enough fertility in the earth to grow and mature an ear of corn or a boll of cotton.

But the Delta country can and does produce one and two bales of cotton an acre; every rain and flood in the Ohio and Missouri River valleys brings downstream more silt and loam to add to its fertility. The eroded and depleted tenant farms in the hills do well to produce from one-eighth to one-half bale of cotton an acre; every bale that is gathered from these hardscrabble acres hastens the land's depletion.

The Negro tenant in the Delta receives as much as two hundred dollars a year for his labor; most of the hill-country white tenant farmers consider themselves fortunate when they receive a hundred dollars for their year's work.

There is nothing extraordinary in seeing poverty walking hand in hand with luxury, sterility with lushness. It is an everyday sight in the South, as common as weeds and flowers, and every region in America furnishes comparable contrasts. Likewise, there is no goal or interest to be gained by attempting to make out a case either for or against the South.

What has happened is that the plantation system has been wringing the blood and marrow from the South for two hundred years and, as fast as that is accomplished, the institution of sharecropping is being set up as a means of extracting the last juice of life from its prostrate body. It so happens that there are now more than ten million persons in one and three-quarters million tenant families in the grip of this system. It may

or it may not be a coincidence that many of them are lacking in food, clothing, and houses; wanting in education, health, and hope.

Farm tenancy, and particularly sharecropping, is not self-perpetuating. It can survive only by feeding upon itself, like an animal in a trap eating its own flesh and bone. The only persons interested in its continuation are the landlords who accumulate wealth by extracting tribute not from the products of the earth but from the labor of the men, women, and children who till the earth.

The white tenant farmer has not always been the lazy, slipshod, good-for-nothing person that he is frequently described as being. His shiftlessness, when apparent, is an occupational disease of which he is generally well aware. There are times when he will readily admit that he is improvident and in the habit of putting off to a later day a task that could just as well be done at the moment; and he will add casually that most postponed tasks are never begun, much less completed. There are times when he is even proud and boastful of his slothfulness.

This same white tenant farmer grew from child to boy to man with many of the same ambitions and incentives that motivate the lives of all human beings. He had normal instincts. He had hope.

Somewhere in his span of life he became frustrated. He felt defeated. He felt the despair and dejection that comes with defeat. He was made aware of the limitations of life imposed upon those unfortunate enough to be made slaves of sharecropping. Out of his predicament grew desperation, out of desperation grew resentment. His bitterness was a taste his tongue would always know.

In a land that has long gloried in the supremacy of the white race, he directed his resentment against the black man. His normal instincts became perverted. He became wasteful and careless. He became bestial. He released his pent-up emotions by lynching the black man in order to witness the mental and physical suffering of another human being. He became cruel and inhuman in everyday life as his resentment and bitter-

ness increased. He released his energy from day to day by beating mules and dogs, by whipping and kicking an animal into insensibility or to death. When his own suffering was more than he could stand, he could live only by witnessing the suffering of others.

The institution of sharecropping does things to men as well as to land. Conservation of the soil, when attained, will be only half a victory. A man here has his vision of life impaired by a lack of education, a man there has his vision of life restricted by ill health and poverty. But no man, providing he is normal mentally and physically, is a member of an inferior race specifically bred to demonstrate such characteristics as indolence and thriftlessness, cruelty and bestiality. Plantation- and tenant-farm-owners alike are to be held responsible, and in the end to be called upon to answer for the degeneration of man as well as for the rape of the soil in the South.

The white tenant farmer lives in a flimsy house and eats too little of the right kind of food, not because he wishes to, but because he has no other choice. If he has six or eight children—and he probably has or will have before he dies—and if the house has only three rooms—and it is more likely to have that number than four or five—there is also the probability that there are only two beds in the dwelling and that half the family must sleep on the floor.

If there are only enough warm clothes to dress three or four of the children in winter, the others must stay at home instead of going to school. If in the spring and fall half the children in the family are needed to help produce and gather the crops, the demands of the farm come before the advantages of the school, the landlord's cotton comes before education.

The white tenant farmer might have acted differently under other circumstances but, when the time came, he was moved by necessity and not by choice. That time comes when bread and meat and shelter are at stake. That time comes also when he must go out to find a husband for

his twelve-year-old daughter because by placing her in another man's charge there will be one less mouth for him to feed, and more for those others who look to him for food. He is once and for all a victim of circumstances, the hard and fast rules governing the lives and thoughts of those men and women who are the slaves of sharecropping.

In Emanuel County, Georgia, there is a sharecropper whose name is John Sanford. He is forty-seven years old, and he has worked on tenant farms since he was a boy of eleven. He was born in Emanuel County and has never left it except for infrequent trips to near-by towns.

Sanford has been married twice, his first wife dying after the birth of her first child. He has already had four children by his second wife, who also had one child by her first husband. Inevitably they expect others to come, since both are resigned to the conclusion that there is no way to stop having them. There are ten persons now living in the Sanford home. Sanford's son by his first wife married his wife's daughter by her first husband. This union has produced two children. These four live in the house with Sanford and his wife and their four children. The building has four rooms.

Sanford is a sharecropping cotton farmer. He has been sharecropping since the age of twenty, first on one tenant farm and then on another, for twenty-seven years. Once he made enough to buy two beds, half a dozen chairs, a dresser, a washstand, and the kitchen stove. Another time he made enough to buy cheaply a second-hand automobile. The furniture has lasted, except for three of the chairs; the automobile did not last. He does not own anything else, except a change of clothes and a few odds and ends. His wife cuts his hair; he pulls the children's teeth when they begin to bother. He has a form for making concrete grindstones; and when he can get the cement, he makes several every year to sell to his neighbors.

Three times a day the family eats cornbread and molasses. With one of the meals they generally have meat with the cornbread and molasses.

[77]

The meat comes from one of the hogs running at range, since some of the hogs belong to him, although he does not know how many do; or the meat comes from a rabbit caught in a rabbit-gum. They have twelve or fourteen hens and a rooster; every year his wife saves enough eggs to make two or three sittings, and the rest of the eggs laid are used to make cornbread batter.

The twenty-acre farm is worked on shares. The landlord furnishes a mule and half the fertilizer used; he furnishes also half the seed for corn and cotton. One of the acres is a canefield, planted every year to supply molasses; the landlord does not take a half-share of that. There is also a garden, about a quarter-acre in size, planted every year in cabbage, turnips, and sweet potatoes. There are several acres of wasteland on the farm. Some of it has grown up in brush; some is gully-washed. Sanford has no cow, nor has he had one for six years.

The land that Sanford farms borders a brook that runs most of the year. In midsummer it usually runs dry for a month or six weeks. The land slopes upward from it, away from the brush and undergrowth that hide it from view. The soil is sandy. When Sanford first began farming it, the soil was fairly productive, making almost, in good seasons, a bale of cotton to the acre. After seven years, the length of time he has farmed it, the rains have washed much of the loam and top-soil away, and what remains is sandy white earth that becomes whiter after every rain. The sand acts as though it were a filter. The fertilizer that is mixed with it each year in the spring produces what cotton there is to gather in the fall.

Sanford has never made any money, as making money goes in the United States, except during the two years when he had enough left over after food and clothing to buy the furniture and the automobile. He has sharecropped for twenty-seven years, on seven or eight tenant farms, but there has hardly ever been enough to buy food and clothes

for the family. He raises four acres of corn each year, half of it going to the landlord, and half being ground into meal to make the cornbread with.

He raises watermelons and keeps them all. There have never been enough to sell, and sometimes the crop is stricken with a blight that spoils all but two or three dozen.

Twelve of the twenty acres are planted in cotton every year. With the help of his son by his first wife, his son's wife, and his own wife, and, when needed, of their children, he grows cotton. He grows cotton as though cotton were food and drink and wine and music. When he can make a pound of cotton, he has made a little sugar for the table, a little tobacco for his pipe. Cotton will keep them and, next to corn and cane, nothing else can. He plants cotton, cultivates it, and picks it; he works every dry day during the season from dawn to dusk. The last crop was an average one. He made three bales of cotton on twelve acres.

After dividing the cotton in halves with the landlord, Sanford's part amounted to six hundred and forty pounds of lint. The ginned cotton was sold for ten and a quarter cents per pound. The seed did not amount to anything; his share had to be kept to plant the next year's crop. He received, in cash, sixty-five dollars and sixty cents for his crop of cotton. He received also, as his share of the government's crop benefit payment, four dollars and eighty-eight cents. The two sums made a total of seventy dollars and forty-eight cents. He did not receive any other money during the year.

Seventy dollars and forty-eight cents for his year's labor bought Sanford and his family some salt and pepper, snuff for his wife; some sugar and coffee-and-chicory; it bought smoking tobacco for the boy and himself, some candy for the children; it bought several yards of gingham, thread, and buttons for his married daughter; two dresses for his wife, and a pair of shoes; material to clothe three of the children so they could

attend school; it bought several bottles of 666 medicine, a cane knife, kerosene, and stamps for letters to his wife's relations.

There were several articles which his wife expressed either a wish or a need for. One of them was soap. Soap could be made from hog fat, but all the hogs ran at range, and the ones that were caught and butchered supplied lean meat but not enough fat for soap-making. Clothing was another. Most of the time during the cold months the children took turns going to school, since there were not enough coats for all.

Sanford works hard. Not as hard as some men; harder than many. He was the son of a tenant farmer, and he learned from childhood from his father that tenant farming required all the energy a man could bring to it. He works a little harder each year, because the soil grows thinner after every rain, because the children grow larger and ask for more food, because he is not satisfied with what he makes.

John Sanford is not the kind of sharecropper a landlord takes pride in. He has grown surly. He accuses the landlord of weighing the cotton short. He tells the landlord he wants more than half the cotton because making a crop requires more labor on farmed-out land. The landlord does not visit him any more as he once did; now he comes only two or three times a year to see what condition the dwelling is in, to see if Sanford has cut any of the timber in the pine grove on the hill. He thinks Sanford might be a dangerous person to have around some day.

Sanford is not a good farmer now. There is no incentive for him to take care of the land. The erosion could have been checked by terracing. The last time he terraced a cottonfield he was living on a tenant farm three miles away. He also put new posts in a fence, and cleared ground for a new garden. When the terracing and fencing and clearing were finished, the landlord told him he was acting as though he owned the place, and that it would be a good thing for him to move off the farm before he got that idea too firmly fixed in his head. He left that farm and moved to his present place.

After twenty-seven years of sharecropping, Sanford might have become lazy and shiftless, as many men do. He might have become broken in health, unable to stand two hours' work in the sun. As it is, he is a little lazy, but still energetic enough to work in the cotton when the cotton needs it. He cannot stand the sun so well as some men now, but by putting green leaves in the crown of his hat he can work through the hottest part of the day without stopping.

He might have become much lazier than he is. Instead, he became resentful. He became critical. He wanted to know why a bank would not lend him enough money to start buying a farm of his own. He wanted to know why landlords were afraid to let sharecroppers terrace and take care of the land. He wanted to know why he could not get credit at a store. He wanted to know why it was that a landlord would give a Negro sharecropper the best land, taking it away from a white sharecropper if necessary. He wanted to know, finally, why all the white sharecroppers in the country did not get together and run all the Negroes out.

He is of little or no value to his landlord. He has talked about renting some cotton land in another part of the county, but has not made any efforts to find land to rent. He has tried to find a new landlord who will give him a farm to work on shares, but most of the men he has seen are afraid he will not be able either to make enough cotton to pay the rent on shares, or to support his family, or both. They are afraid they would have to supply food for the family once Sanford moved on their land.

As long as the land was fertile enough to produce a living, Sanford was able to make a living. Now the land is eroded and washed thin, Sanford himself is almost broken in health and spirit, and he has become resentfully outspoken in a country where talking out loud against the agricultural system of farm tenancy signals a man's own doom. It is the last cry of a man defeated by sharecropping.

One of these days the tractor and the mechanical picker are going to catch up with cotton, but by that time it's going to be too late to help the tenant farmer. He'll have ruined the soil for raising any other crop, and broken his back, to boot. Don't ask me whose fault it is. I don't know. I don't even know anybody who thinks he knows. All I know is that one man out of ten makes a living, and more, out of cotton, and that the other nine poor devils get the short end of the stick. It's my business to sit here in the bank and make it a rule to be in when that one farmer shows up to borrow money, and to be out when those other nine show up. I don't even know how to make money raising cotton myself. If I knew, I'd be out there doing it, instead of sitting here trying to lend money to one farmer while trying to keep nine others from knowing I don't want to lend them money. Some nights I can't sleep at all for lying awake wondering what's going to happen to all those losing tenant farmers. A lot of them are hungry, ragged, and sick. Everybody knows about it, but nobody does anything about it. The tractor and the mechanical picker, if it comes or if it doesn't come, won't make any difference in the end. The world can get along without cotton as soon as something comes along that's a cheaper substitute, and as soon as it does, cotton will pass out just like spinning-wheels and one-horse buggies. What it all adds up to is that cotton has ruined ten million people living in the cotton States, and it's going to ruin a lot more before it's through. The rest of the country doesn't care what happens to all these people. They might make a show of caring, but they've got troubles of their own, and a man's own troubles are more important to him than somebody else's. If the government doesn't do something about the losing cotton farmers, we'd be doing them a favor to go out and shoot them out of their misery.

AUGUSTA, GEORGIA

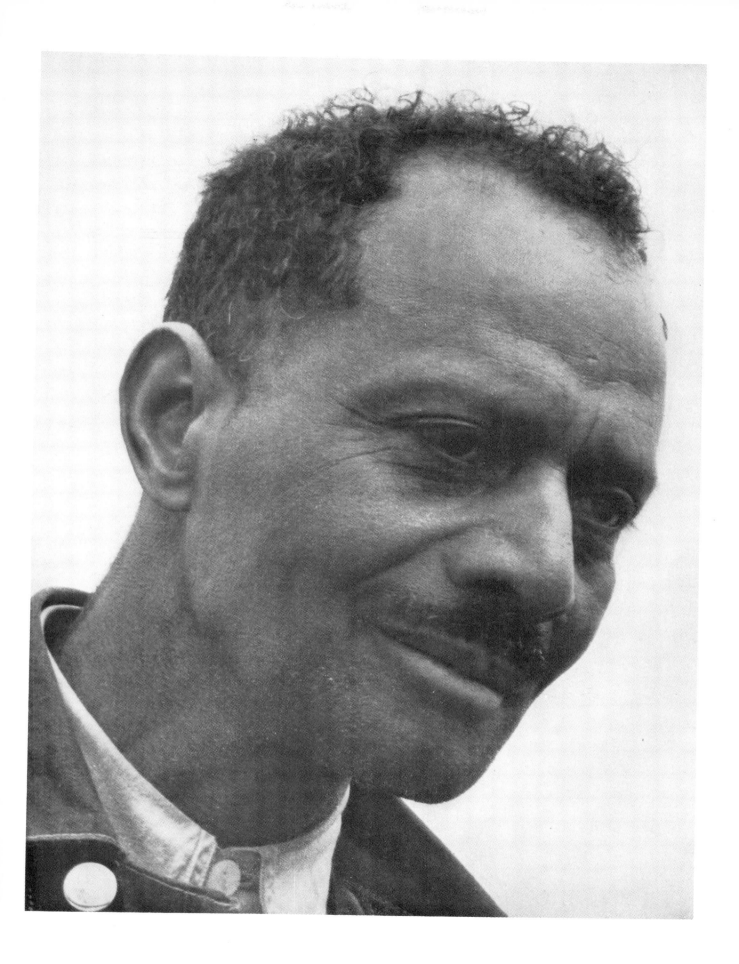

Arlington, Tennessee

"We own the homestead. It has a five-room house and fifty-three acres of land. We keep chickens, hogs, a horse, two mules, and two cows. There's a pasture and a half-acre vegetable garden, and my wife has a flower garden."

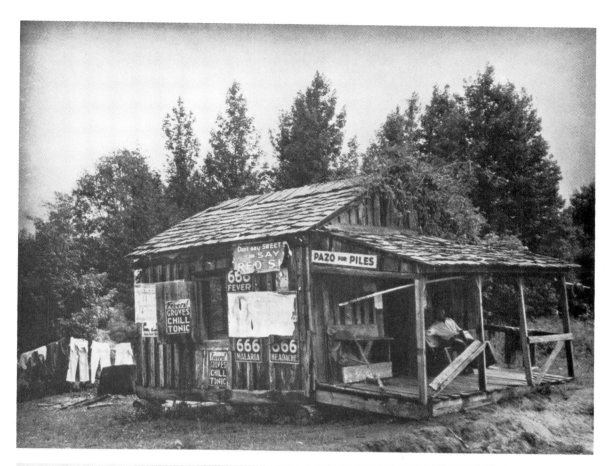

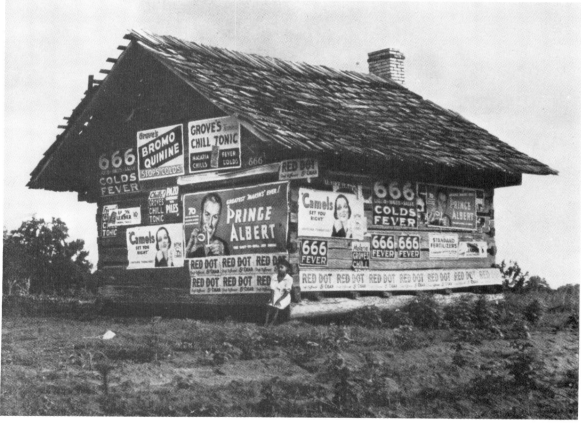

Montgomery, Alabama

"Of course I wouldn't let them plaster signs all over my house, but it's different with those shacks the niggers live in."

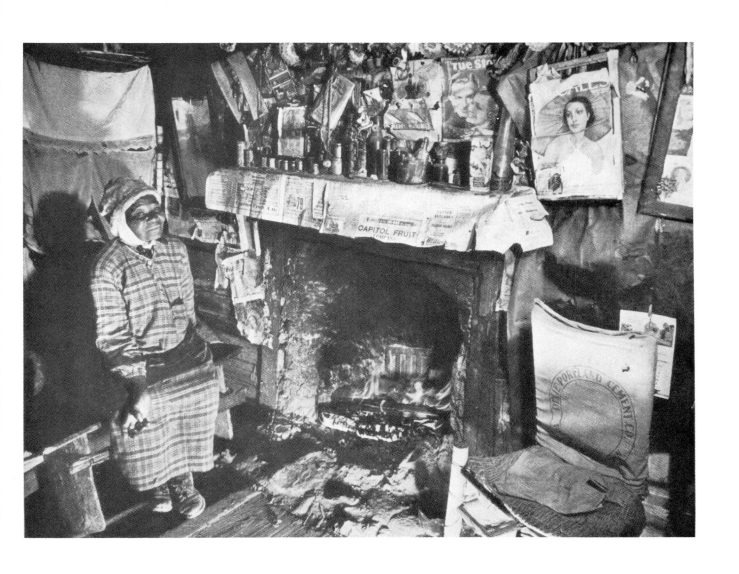

Johns, Mississippi
"My husband done took himself away last year, and the chickens whipped me out of all my corn."

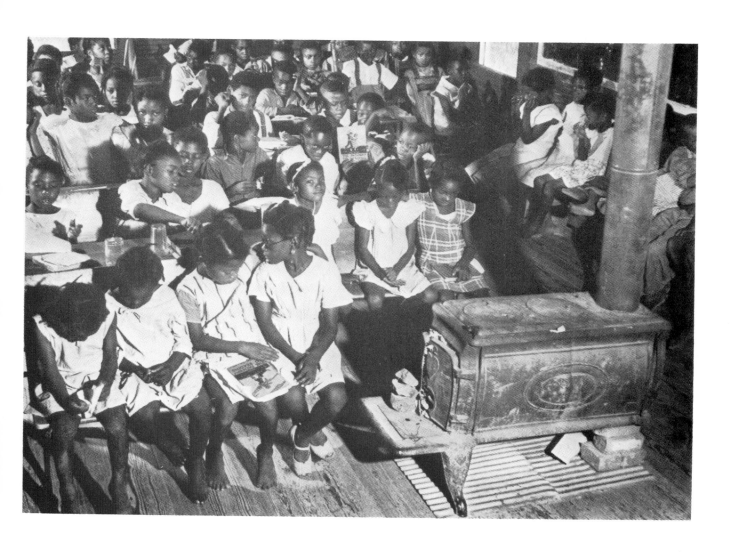

Scotts, Arkansas

"And so the fairy godmother in the storybook touched the little white girls with her wand and they were all turned into little princesses."

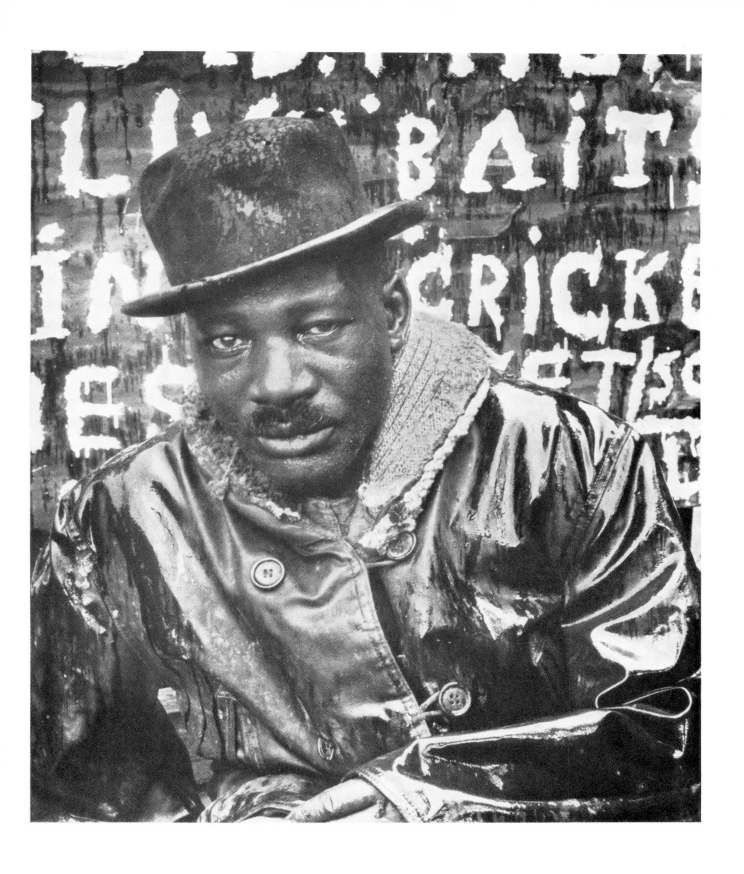

Augusta, Georgia

"Everybody likes to fish, but nobody likes to rustle up bait, so I expect that's why I make a sizable living."

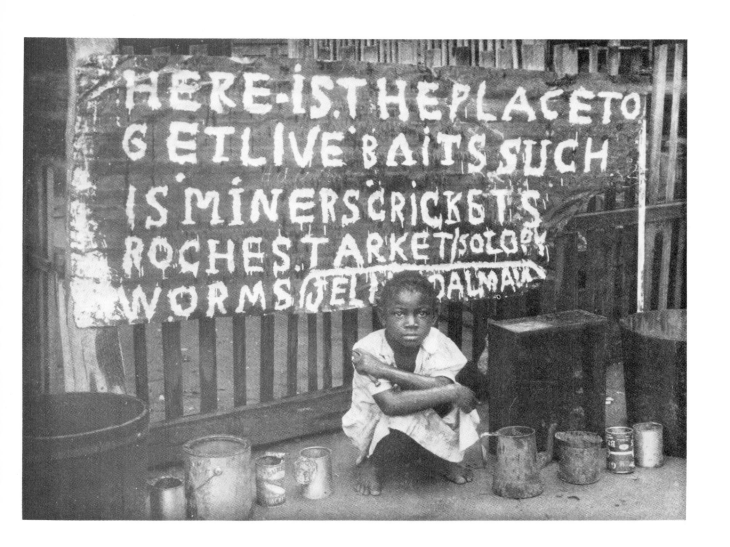

Augusta, Georgia
"She's caught so many crickets she's got so now she sets like one."

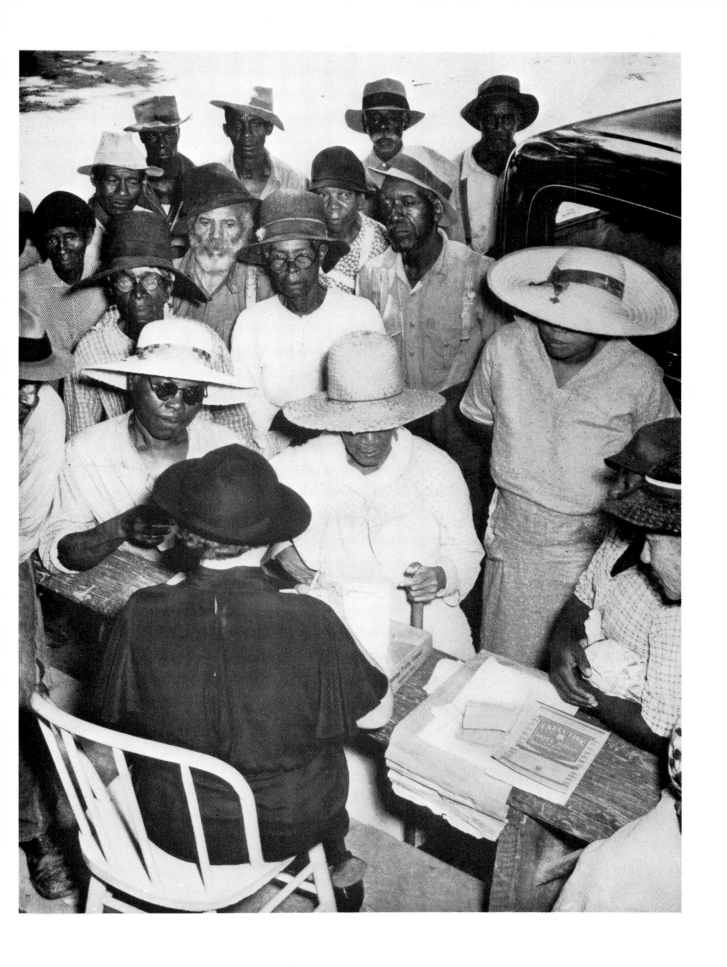

Bosporus, Mississippi

"Four dollars a month old-age pension isn't all the money in the world, but it's like holding out a helping hand to the colored people."

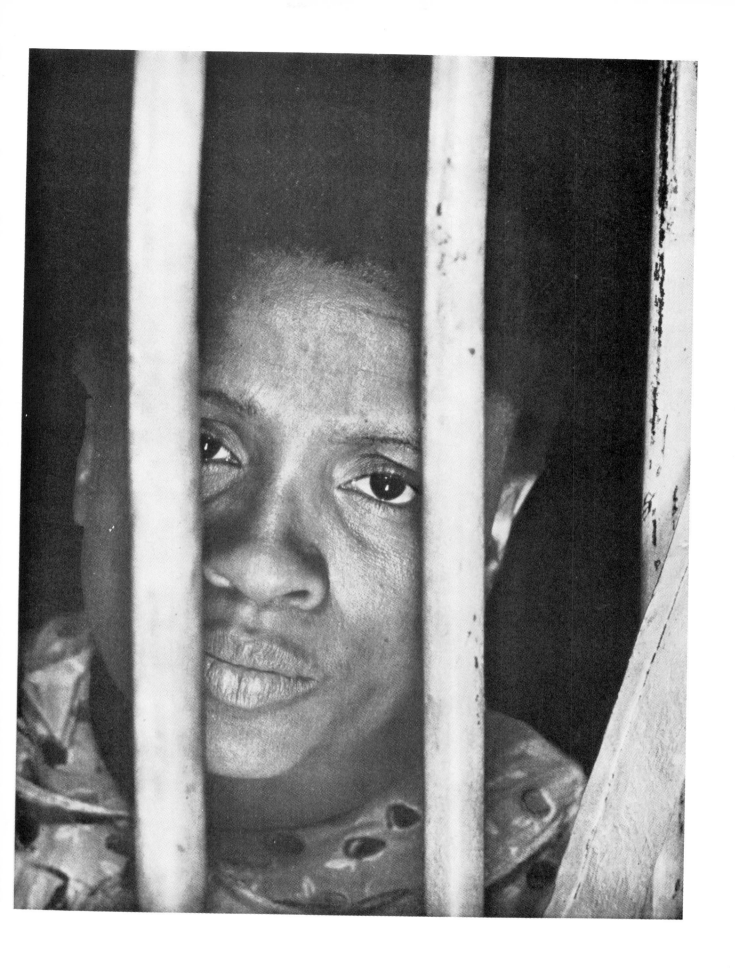

St. Tammany Parish, Louisiana
"I've only been misbehaving."

Nettleton, Arkansas
"I used to be a peddler until peddling petered out."

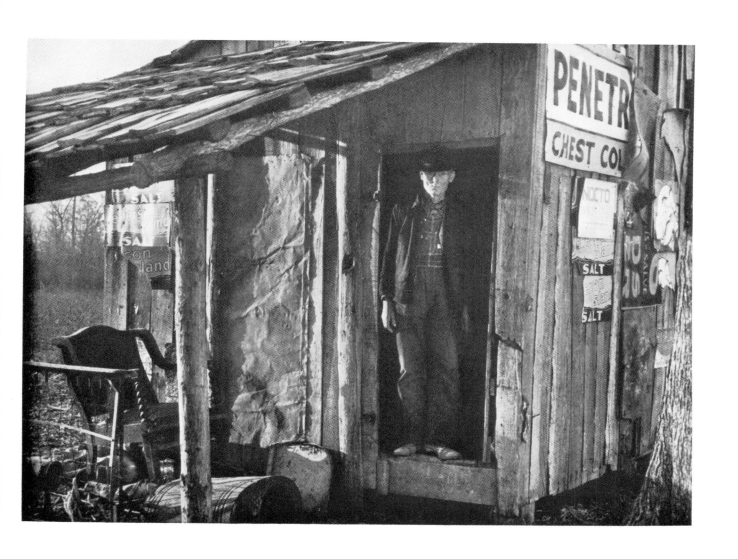

Nettleton, Arkansas

"My son and his wife sleep in the bed, and I was all right on the floor until the high water floated my
mattress away."

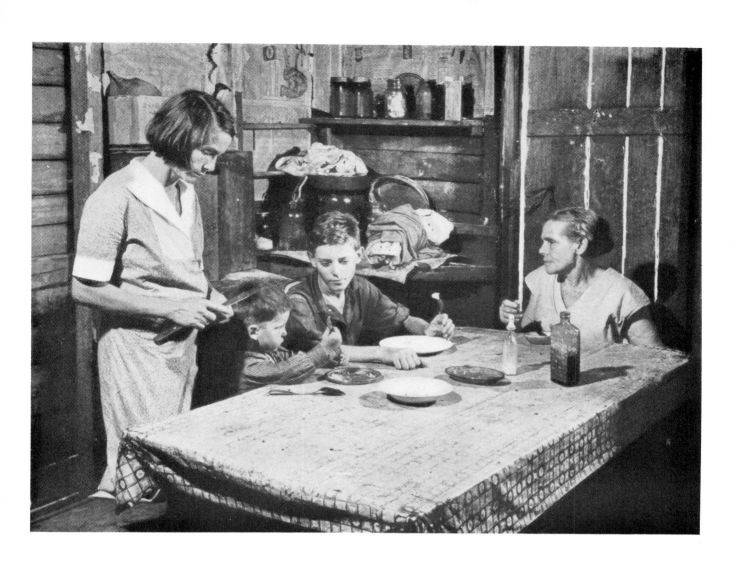

Okefenokee Swamp, Georgia
"The littlest one gets taken care of."

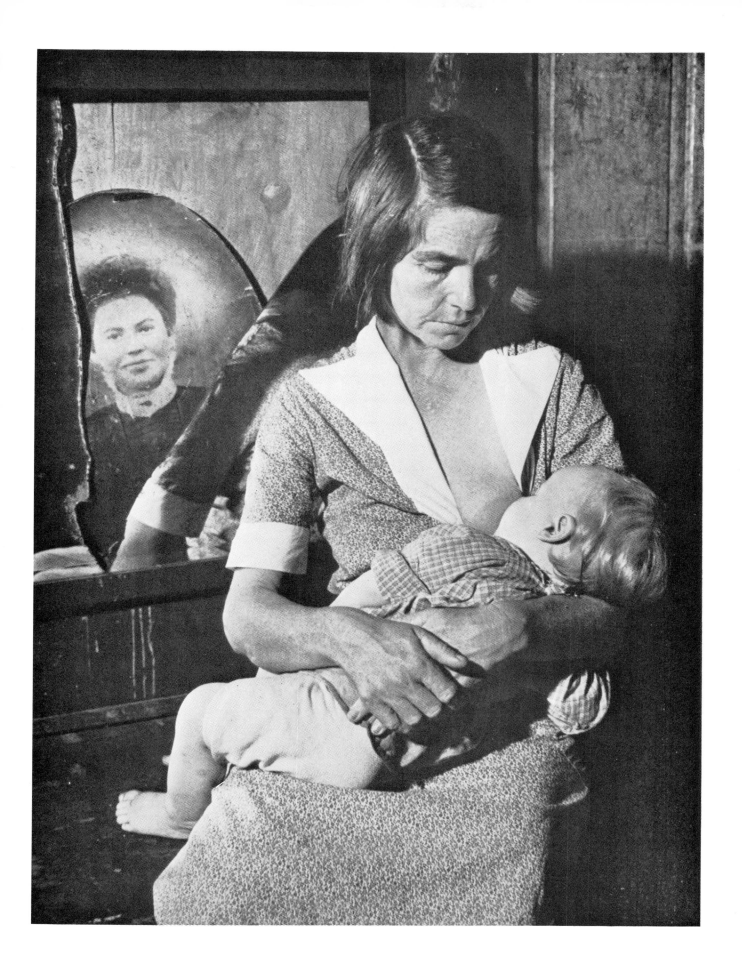

Okefenokee Swamp, Georgia

"Every month the relief office gives them four cans of beef, a can of dried peas, and five dollars, and the old lady generally spends a dollar and a half of it for snuff."

IV

Sometimes it don't seem possible that we're living at all, especially when I wake up in the morning and see the children getting up and dressing and walking around in the kitchen where there's hardly a crumb of food. They make a fire in the cook-stove and I scrape together a little corn meal, when there's any to scrape, and I cook it with salt and water. Once in a while we have some molasses, or maybe just some sugar-water to eat with it. When noontime comes, they start another fire, and I cook some more cornbread. A lot of times lately I've just sat and wondered if there's anything else in the world to eat. I know there must be other things in the world to eat, because the rich wouldn't eat cornbread, and I wouldn't if I could help it. Not just cornbread and nothing else. Once in a while we have some store-bought canned beans, just one or two cans among us, and that don't go far when there's nine hungry children besides me. The two oldest boys manage to earn a little money somehow, and they bring home all they make. Altogether, what money there is comes to two or three dollars a week. We eat on that, except for the twenty-five cents a week house-rent I pay the landlord. We've been getting along somehow for three years since my husband died. Every time it rains hard all of us have to crawl under the house to keep from getting wet, because I don't reckon there's a landlord in the country who would patch a roof for only twenty-five cents a week rent.

PETERSON, ALABAMA

Now that the landlords have inveigled their tenants into wearing tight shoes that pinch the feet, what the South has most to fear are well-meant but irresponsible plans for its regeneration. The American mind is by this time so accustomed to weeping over lost causes that in this instance there is likelihood of the sharecropper becoming just another figure in a sentimentalizing nation.

The everyday sharecropper is anything but a heroic figure at present; if he continues being the nation's under-dog, that is what he will become. As an individual, he would rather be able to feed, clothe, and house his family properly than to become the symbol of man's injustice to man.

Where a great many individuals live and work side by side, performing more or less the same tasks, their lives in general conform to a pattern. The uniformity of their lives is all the more noticeable when their education, earnings, and environment are similar.

If there is in real life a man who is representative of the million and a half heads of tenant-farm families in the cotton country, he is a sharecropper lacking most of the virtues the human race at some time or another pats itself on the back for possessing. A defeated, frustrated, resentful person in the latter years of his life is not likely to have a strong character.

As a young man he began life with hope and confidence and the will to work and succeed. He was strong physically and mentally alert. He had been raised on a farm and had grown to feel a closeness to nature from which no vision beyond the horizon could alienate him. Ever since the day when, as a boy, he had planted watermelon seed in the earth and had watched the seed swell and burst and send a tender shoot into the sunlight above, he had known that planting and cultivating and harvesting were to be his life.

When he came of age, he left his father's home and went to work on another farm. At first he worked by the day for wages, making a dollar for his labor and living in a tenant house rent-free. He worked for

wages, planting cotton and corn for another man, cultivating it and harvesting it, for two or three years. Then he married. By then he wished to have a farm of his own. He and his wife did not have enough money to buy the land, and so the next best thing was to rent the land.

Renting a cotton farm has always been a risky undertaking. A poor season one year will put a man into debt, because he will have to pay rent whether the crop is good or bad. In this case, there was barely any crop at all. He had to give up everything he made, but that still was not enough to pay the rent. He promised to pay the rest when he gathered his crop the following year. But he and his wife had to eat while waiting a year and working just the same to make a new crop grow and mature.

There was nothing to do but for him and his wife to move off the rented land and onto a farm where they could sharecrop. By becoming a sharecropper, he was able to secure enough credit from the landlord to buy food. The other advantage in becoming a sharecropper was that even if the following season were a poor one, they would at least be able to keep half of what they made.

At the end of the year they were able to pay for the food they had bought on credit, but there was not enough left over to pay the balance owed for rent of the farm they had worked the previous year. It was never paid.

Sharecropping began. It was necessary for his wife to work alongside him to help with the crop, because they had to raise more cotton than ever before in order to have enough of their own, after half of it was given to the landlord. A child was born. His wife had to help pick the cotton the day before the birth and the day after, because the cotton had to be gathered before a hard rain would have a chance to come and beat the cotton out of the bolls.

After five years of sharecropping, he was beginning to see that he was not making much progress. There were three children by then, and another was coming, and food had to be provided. He worked harder to

make more. They ended another year, this time with not much more than enough corn meal and molasses to get them through the winter, because it had been a dry season again, and only half a crop of cotton was made.

Things were no better after ten years. He moved to another farm, a larger one, because by that time four of the children would soon be big enough to help plow and cultivate, chop cotton and pick it. And, too, because there were now six children in the family and a lot more food had to be provided. But the land was no better than the other, and probably worse than the land they had left.

He worked as hard as he could for five or six years on the new farm, but sharecropping on farmed-out land was making him worse off every year. Their clothes became a little more ragged, their faces became a little more haggard, and their confidence in the future was lost in the struggle to survive for the present.

The children, eight of them by that time, had to have clothes in order to attend school. They had to have something to eat, if nothing more than cornbread and molasses. The sharecropper worked harder than ever, getting up earlier in the morning and staying in the field later in the evening. That year's crop did not provide any more than had the previous year's crop. Conditions were better, if anything, than the year before, because there was plenty of rain, but not too much, and the boll-weevils did not inflict as much damage as they had the year before. The trouble was that the land was farmed-out. It was producing less cotton every year.

When he saw what had happened to the land, he tried to find another farm. The fields were thin-soiled and eroded. It was too late to terrace the land; the fertility could not be restored during his lifetime.

But when he went in search of another farm, none of the landlords he talked to was interested in having him on their land. They said they had all the sharecroppers they needed, but he had heard the same men say,

when they did not know he could overhear, that they could always find room, or make room, for a good sharecropper especially if he were a Negro.

None of the landlords told him why, but he noticed that Negroes were living in the tenant houses that formerly white sharecroppers had lived in. He saw Negroes working better cotton land than he could work. He was angry about that.

He and his wife tried to make the best of things. But the spirit was gone. It was too late then to start out as he had done as a young man. There was no desire to work their hearts out when they knew beforehand that, no matter how hard they worked, the land would give them less one year than it had the year before, and that even that had not been enough to provide the food their stomachs craved.

Resentment came into their lives. The landlord lived well, dressed well, ate well. His wife had clothes that were not ragged, and his children attended school in shoes and stockings and in coats and hats as well. The Negroes all around them did not have to work so hard, yet they had more.

He began talking to his neighbors, sharecroppers and white like himself, about the Negroes. Some of his neighbors were no better off than he was; some of them were better situated, some worse. A lot of them felt the same way he did. Most of them thought, and said, the Negroes ought to be run out of the country. Nobody thought to ask why the landlords should not be held responsible for their condition. For one thing, the landlords were white men like themselves. The landlords went to church and prayed and sang hymns just as they did. All white men were superior, and resentment had to be taken out on people who were held to be inferior. It was easy to scare a Negro. Negroes had been made to fear the white man.

By this time the sharecropper's face had become drawn and tight. There was bitterness molded into his mouth and cheeks. He woke up

with it in the morning, lived with it through the day, and went to sleep with it at night. He was broken in health and spirit. He was down and out. He did not expect anything better as long as he lived.

The house was dirty and disheveled. He and his wife no longer had any pride in their home or in their appearance. They went unwashed. Itch and pellagra spread among them. He sat in the shade, his hat pulled over his eyes, and watched the spring come, the summer go. The older children struggled with the cotton. It did not matter much to him then. He found a shack several miles away. He got the owner's permission to live in it on the promise of making the children work out the rent in the cottonfield.

The children, old and young, worked for the landlord to pay the rent on the shack. After that, one of them would find a day's work occasionally, and earn enough to buy cornmeal and molasses, sometimes meat.

The shack was without a floor. There was only one bed. They lived in two rooms, the eight of them. The youngest child died of pneumonia. The two oldest boys left home one day and did not come back again.

He did not have anything to do, because there was no land he could farm. Sometimes he would walk down to the store at the crossroads, a few miles away, but most of the time he stayed at home, sitting in the shade with his hat pulled over his eyes.

Somebody told him about a Negro who had got into trouble with a white man. It had happened five or six miles away, and he started out walking as soon as he heard about it. He stopped and talked to several men along the way. They were sharecroppers, renters, field hands, and leasers. All of them thought it was a good time to teach the Negroes a lesson. It might make a lot of them move away, and that would give the white people a chance to move on to good cotton land. There was nothing like a lynching to put the fear of God into Negroes and scare the daylight out of their souls.

The sharecropper's life generally follows a well-defined course. He begins life just as most men begin, hopefully, eager, confident. He works with all the enthusiasm and zest of youth. Then something happens; what it is, he does not always know. The first indication that something has happened is when the children first beg for food, then cry for it. It is then that he knows something has happened. He works harder than ever before in his life after that realization has come to him. But there is still no more food, perhaps less of it, and the children continue to beg and cry for it.

Then he looks about him and realizes that the land he has worked all these years has been farmed-out, or that erosion has washed the top-soil away, or that he has broken his health so that he cannot work. Usually all of this comes to him at once. With bitterness and resentment come hopelessness and despair.

It is then, perhaps for the first time in his life, that he looks at the landlord and wonders what it is the landlord represents. The landlord has the power of law and wealth behind him. His word is final. A sharecropper cannot dispute his word, cannot question his honesty. He represents the agricultural system that acquires sharecroppers and mules for their economic usefulness, and disposes of them when no more profit can be extracted from their bodies.

Behind the misery and suffering of the sharecropper's life the landlord exists as real as his own pain and anguish. It is only after he has been tossed aside that he realizes that the landlord, while watching and calculating the slow but certain demoralization, has been making plans to put a younger man, preferably a Negro, in his place. The landlord knows by experience that the sharecropper will have fulfilled his period of usefulness at a certain stage in his life, and that if he helped the sharecropper, he would not be able to operate a profitable farm. Profits, the landlord knows, can be made in cotton only at another man's expense.

Experience and business judgment tell him to turn the old tenant out, and to put in his place a young man, a young man who has just turned twenty-one.

We've been here most of our lives, my husband and me, and I feel like I'm done for, and my husband looks it. If it wasn't for our boy, we just couldn't get any cotton raised to pay the rent. I've got body sickness and can't stand working in the fields any more, and it's all I can do to drag myself around the house and cook a little food. My husband is just no account. He sits there on the porch all day looking out across the road and don't pretend to move. Sometimes he sits there three or four hours, looking like he's dead, but he's not. He's just no account. Me and him both worked ourselves trying to make cotton, and I reckon we're done for. If our boy leaves, there won't be nothing we can do about it, except maybe move to the poor farm. My husband says the land ain't as good as it used to be, and I reckon it ain't. It looks like it is all we can do to make enough to get by on, but sometimes there ain't enough of that. Sometimes I think I've had more than my share of hard living. My daughter is only half-bright, and can't do nothing much more than sweep a room, and she's not good at that. My body sickness just pulls me down, and when I get up in the morning, dragging one foot behind the other is about all I can manage to do. My husband is mean to me. He just sits there on the porch and don't say a thing all day long unless it is to call me a name or something like that. If I could get over my body sickness, I might be able to do a little something. I don't reckon I ever will. All I feel like doing most of the time is finding me a nice place to lay myself down in and die.

TROY, ALABAMA

[114]

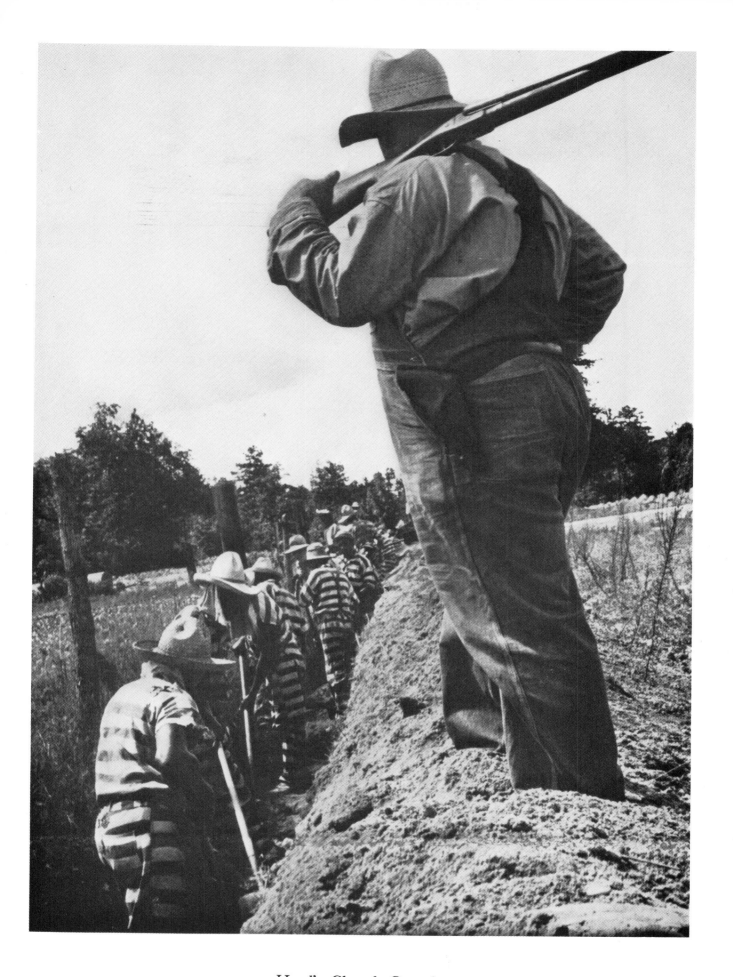

Hood's Chapel, Georgia

"The gang goes out in the morning and the gang comes back at night, and in the meanwhile a lot of sweat is shed."

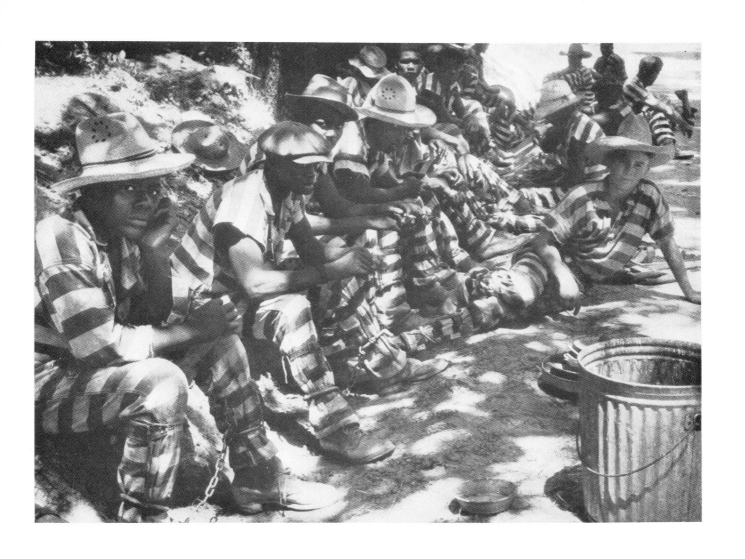

Hood's Chapel, Georgia

"It don't make no difference where you come from or where you're going, because when you're on the gang, you're here for a long time to come."

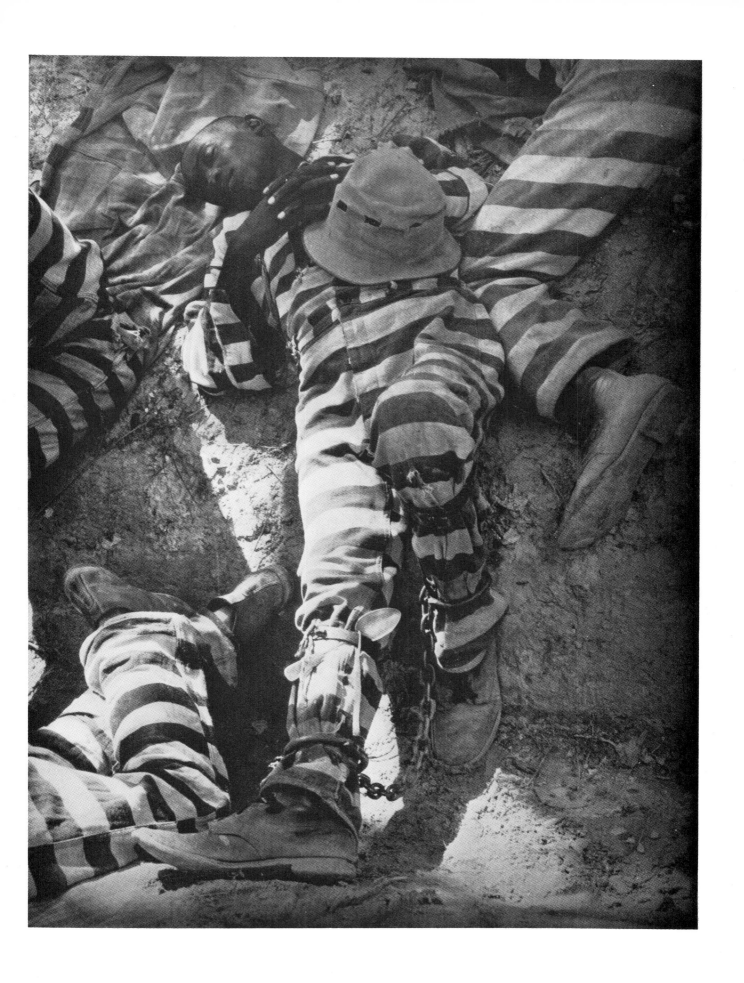

Hood's Chapel, Georgia
"I reckon I was naturally born a black boy in the white man's country."

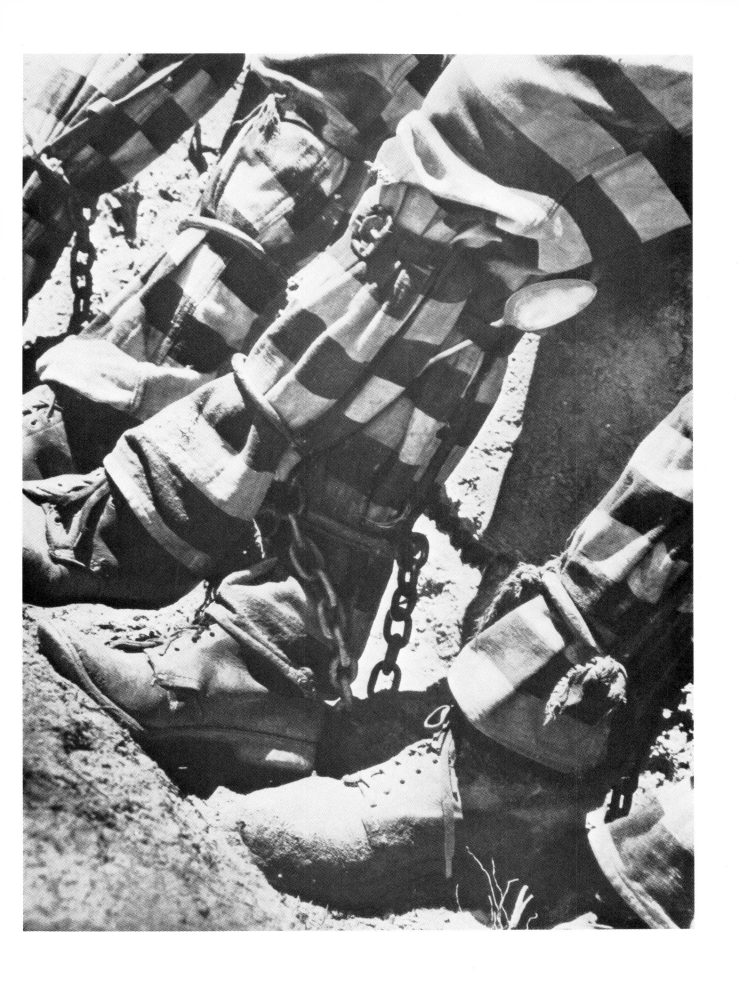

Hood's Chapel, Georgia

"They can whip my hide and shackle my bones, but they can't touch what I think in my head."

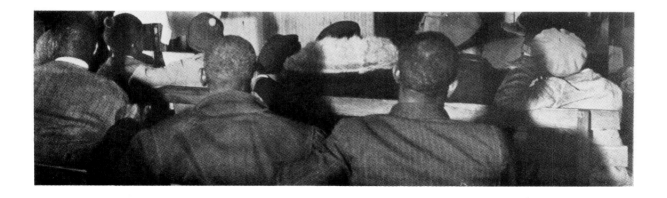

College Grove, Tennessee

"Now it says right here in the Big Book that you'll be sorely regretful on Judgment Day if you don't show yourself on the side of the Lord."

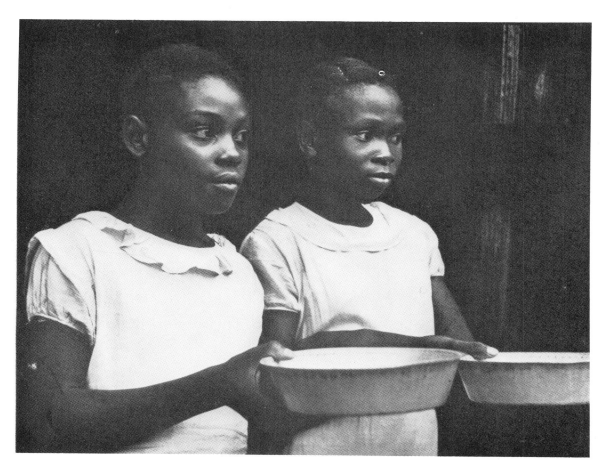

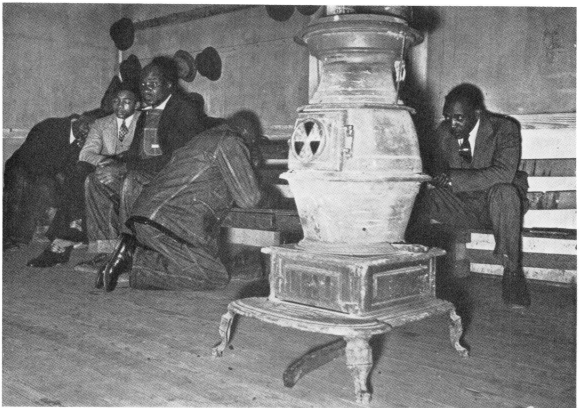

College Grove, Tennessee
"The Good Man above sure does listen to the prayers of contributioning people."

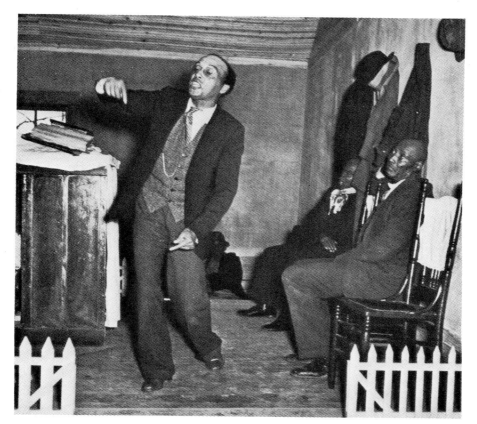

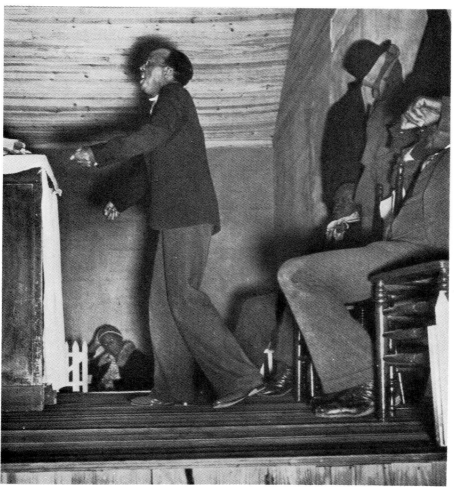

College Grove, Tennessee
"Hurry, folks, hurry! Getting religion is like putting money in the bank."

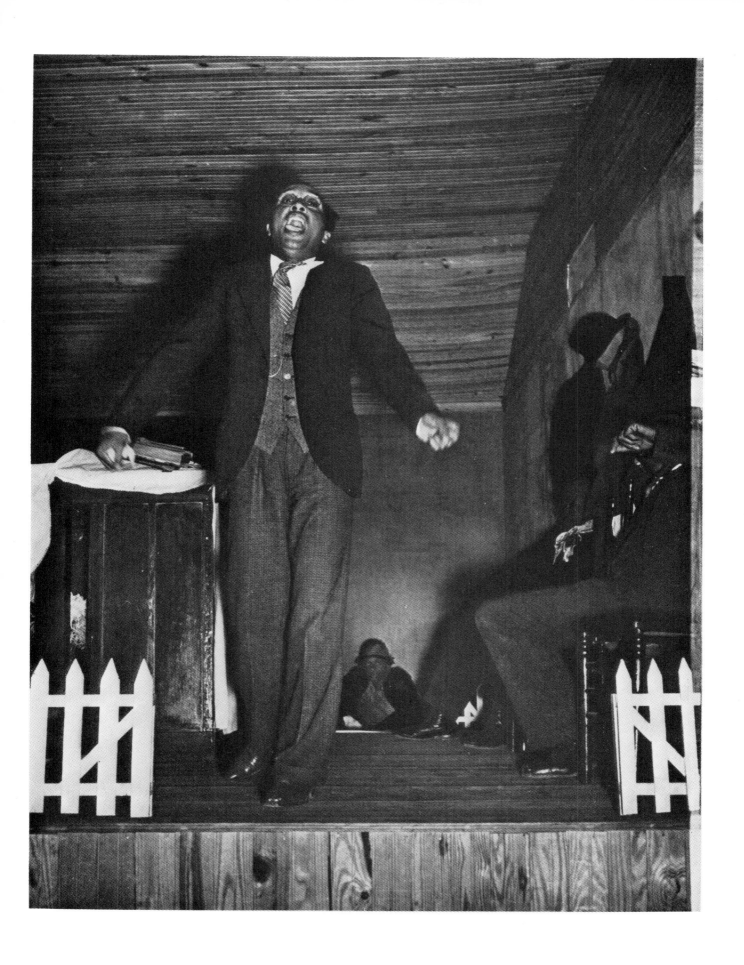

College Grove, Tennessee
"We've got a first-class God."

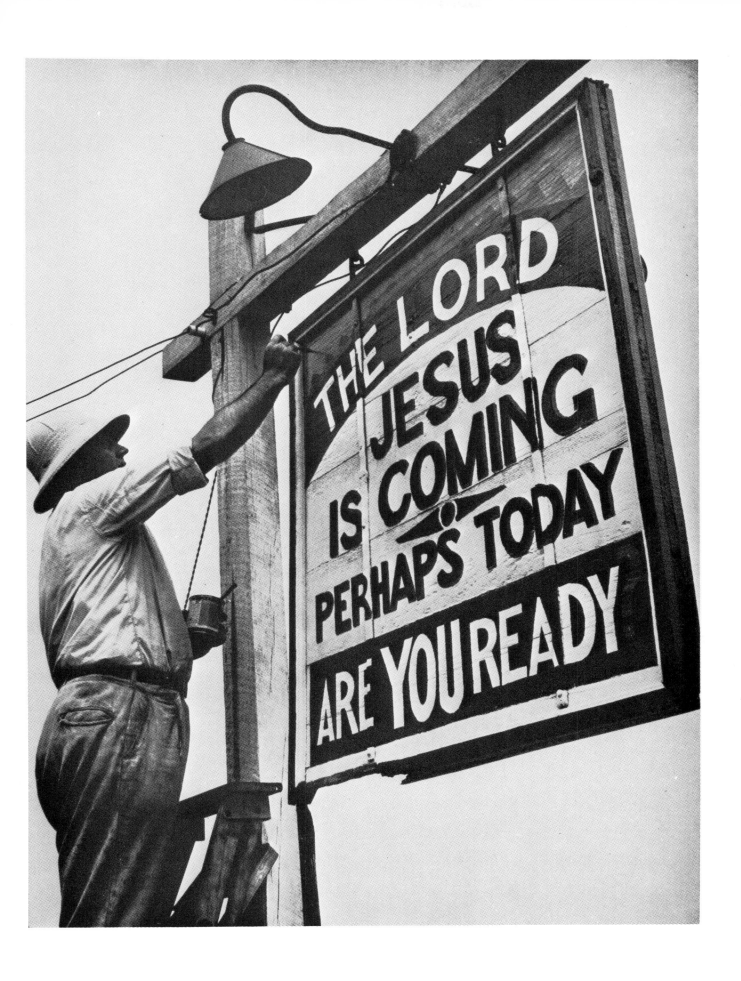

Augusta, Georgia

"It's getting so nowadays people don't ask how good a preacher is at preaching. They want to know how good he is at painting signs."

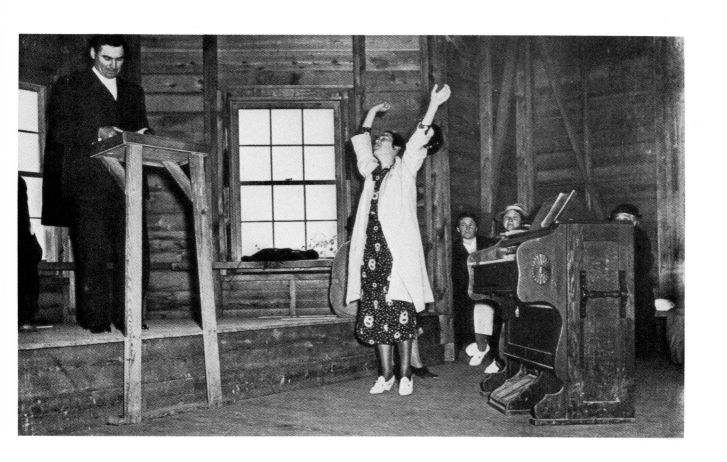

Exminster, South Carolina
"Mildred has on a new pair of shoes today."

Exminster, South Carolina
"Mrs. Peterson is growing thinner."

Exminster, South Carolina

"That's Fanny's boy sitting in the window watching his Aunt Nell come through."

V

I reckon folks from the North think we're hard on niggers but they just don't know what would happen to the white people if the niggers ran wild like they would if we didn't show them who's boss. If I was you I wouldn't go back up North and say you saw us down here trying to catch a nigger to lynch. It just wouldn't sound right saying it up there, because people would get the idea that we're just naturally hard on all niggers all the time. There's a lot of fine ones in this country, but they're the ones who know how to keep their place, and they don't make trouble. This nigger that raped that white girl is a mean one. Of course, that girl is a whore, and everybody knows it, and for all I know she led him on, but just the same she was a white girl and he was a nigger, and it just wouldn't do to let him go. That's why we're out here trying to jump him in the woods. Maybe the sheriff will get him before we do, but it's going to be a race, and whoever gets him first is going to keep him. I reckon you understand how it is now, and if I was you I wouldn't go back up North and say you came down here and saw us trying to lynch a nigger. If you say something like that, people will think we're hard on niggers. I've got niggers working for me, and I get along the best way with them, because they know how to keep their place. If that nigger out there in the woods gets jumped before the sheriff finds him, it will all be over and done with by sundown, and everybody will be satisfied.

<div align="right">KIBBY, GEORGIA</div>

The South, as long as it remains traditionally the land of cotton, will

never be completely understood by the rest of America. It has purposely insulated itself from the world in retaliation for defeat, and taken refuge in its feeling of inferiority. The South perpetrated a feud, which was excusable in the beginning, and now it is guilty of perpetuating the quarrel, for which there is no excuse. It is a feud between the South and its neighbors which neither laws nor man can put an end to, but which can be dissipated only by removing the reason for the ill-feeling. As long as cotton is grown, it will continue to be the symbol of the lost cause.

The South has so little in common with the East and the West that it is remarkable that it has remained a part of the Union. The Union itself is so unsure of the South's loyalty that it does not attempt to enforce its hard-won amendment to the Constitution, and pretends to be looking in another direction when Southern legislatures pass conflicting Jim Crow laws.

In its self-imposed isolation, the South has grown reactionary. At first, this was necessary, from its point of view, to counteract the influences seeping in from the North that would have, had they been welcomed, given approval to outside culture and domination. It is possible that the War was a mistake, and that the victory achieved probably only a technical one. The Union made the mistake of doing the right thing the wrong way when diplomacy might have produced more beneficial results than bullets. As it was, the conflict served to alienate a people.

When the South became aware of the fact that its self-imposed isolation had gone far enough, it discovered that it was not possible to turn about overnight and catch up with the rest of the Union. Industrially and economically the East and West were so far in advance that it looked as though it would be impossible to overtake them. It was this realization that forced the South, for the second time, although involuntarily on this occasion, to impose isolation upon itself.

It returned to the only thing it knew, the raising of cotton. It has industrialized itself wherever industrialization has been possible, but its

steel mills, cotton mills, and paper mills have been able to employ only a small percentage of its population. Its working people are still predominantly tenant farmers.

During the early stages of the reactionary period, farming retreated toward its more primitive forms. It seemed as though the tendency was to present as close an approximation as possible to the plantation system of agriculture. Since the plantation system, because of its use of Negro slave labor, was the original point of contention, cotton farming resorted to the closest imitation of it as a means of getting even with the North. This imitation evolved into sharecropping as it is now seen in all its forms.

The urban South and the industrial areas there have made a partial success of their attempt to drop the customary reactionary tendencies, but the agricultural South is so large and populous that its influence continues to rule the entire region.

Landlords as a class are willing to be misunderstood by the world at large if misunderstanding enables them to continue using tenant farmers as a source of wealth. They are willing to be reactionary, and indeed anxious to be, as long as reaction is a method of fortifying sharecropping as an institution. Although tenant farming has proved to be an anti-social method of raising cotton, the owners of the tenant farms, as well as all those who derive wealth and income from the tenants, can be expected to defend it as a highly desirable practice.

The reactionary movement in the South finds its most apparent fruition in politics. The combination of political reaction and sharecropping has produced what is perhaps the most colorful collection of rabble-rousers in modern history. The Southern politician learns almost from the cradle what the landlords want and what they will pay to have their wants catered to. When that has been learned, it does not take him long to find out what it takes to get the tenant farmer's vote.

The politician cannot give the landlords what they want without the

votes of the tenant farmers, and the successful politician has no use for the word discretion when it comes to making promises to tenant farmers in payment for votes. Party principles are cast to the winds, since nearly everybody votes Democratic, and the issues of a campaign become personal in the absence of any party conflict.

From the most insignificant county office through the governorship, the political campaign hinges almost entirely on a man's ability to win votes by stirring up the sympathies and prejudices of primitive people. Many a sheriff has been elected to office on the statement that he alone among all the candidates can by means of intimidation keep the Negroes from raping the wives and daughters of the voters.

No means a politician employs to gain votes from ignorant people will cause wonder when a candidate for county tax-collector can beat five other job-seekers for the office by promising to have the price of cotton raised two cents by December. Long before December comes, he is safely seated in office, and when the price of cotton fails to go up as much as a quarter of a cent a pound, nothing can be gained by calling upon the election-winner to explain.

The tenant farmer has little to gain from politics at present, but he usually holds the balance of power, and few politicians could gain access to office without his vote. The ogre of radicalism is generally painted so hideously that few men without economic understanding could withstand the plea to vote for reaction. As long as tenant farmers can be kept from the dangers of outside political thought, the politician knows how to count the votes the day before election. This is much easier to accomplish than it appears, but many tenant farmers cannot read, many cannot subscribe to newspapers, and many who do see newspapers see only those published by the politicians, who are careful to edit the news in a way that best serves their own interests.

Politics furnishes the fireworks, religion supplies the consuming heat. Socially and economically, Southern politics is the razzle-dazzle of

Southern reaction. It can be counted upon to confound and conspire; it can be expected to instill and generate prejudices, and to make capital of the prejudice ignorance produces.

But religion touches the lives of more persons, more frequently, than politics. The backland, pine-barren church-goer is a fervent believer in religion for religion's sake. His religion fits his needs and fulfills his desires. Usually he is a man who, under other circumstances, might have found religion a comforting thought, but not a panacea.

But in the South, in the tenant-farming regions, he made religion serve as a release and escape. The sermons that are preached to him fulfill his desire for a vision of a different life. Once a week he can hear the minister promise him a new life in another world. It gives him something to look forward to during the other six days of hard labor when he and his family do not have enough to eat. The expectation is that in the life promised by religion, he and his wife and children will not be hungry. It excites a man when he is hungry to be told that, for the asking, he can fill his stomach with food. When a minister does not have to appeal to basic reasoning, he can excite men and women as no one else can. He promises that religion will grant all needs and desires, he appeals to the man who wants to escape from the slavery of labor that yields no returns. He can excite the ignorant who live primitive lives to give vent to their feelings by rolling on the floor, shouting, and dancing in the aisles.

Many men accept the church merely to be on the safe side in case there is a life hereafter, after all. They profess to be believers, although their motive is to insure themselves against any eventuality. Tenant farmers in the South profess to be believers for a different reason. They have lived a life of hardships, and anything that offered a reasonable reward for all their years of hard work would be appealing. It is not strange that many times they are savage in their demonstration of gratitude.

[143]

As a mere promise of something in the future, religion has no competitor among tenant farmers in the cotton country. The more primitive the ritual, the more exciting the prospect to primitive people. The Foot Washers, the Shouters, and the Holy Rollers are people who not only get excited over the prospect of living a second time, but who also want to celebrate their second life before dying in this one.

The church exists in fear of the landlord, and consequently it conducts itself along lines calculated to give the least offense to his social, political, and economic creeds. With its membership of tenant farmers, its minister is not likely to preach a sermon reflecting on the ethics of the man who is their master. The minister in such a case fears to preach a sermon pointing out the equality of man and the right of man to receive a living wage for the work he performs.

The failure of the church to preach its own convictions in the sharecropper country has resulted in its becoming a burlesque of religion. For that reason it is not difficult to understand why many of its houses are now places where once a week men and women go to elevate themselves into a state of religious ecstasy that enables them to forget their troubles. Men and women who writhe on the floor, shout until they have no voices left, go through various forms of hysterical behavior, do not do so merely because they believe they are Christians. They intoxicate themselves with a primitive form of religious frenzy that has its closest counterpart in alcoholic drunkenness.

The church is one institution that might have been expected to fight for the welfare of its people. Instead of allowing the fear of the landlord to close its pulpits to fearless expression, it might have become a power in protecting its people from economic exploitation. It has failed to fulfill its mission in the sharecropping region, if the rolling and shouting services it conducts are indicative of its aim, and has become a powerful force of reaction.

Being a social welfare worker in Philadelphia is one thing, but being a union organizer among these sharecroppers is something else again. I thought I had case histories up there in Philadelphia that would make your hair stand on end, but what I've found out down here in Arkansas and Mississippi is the kind of thing that makes cold-blooded murder look like child's play. Trying to put slum people on their feet when they are so down and out they don't care one way or the other is a heart-rending task. You soon get the feeling that they don't expect to stand on their feet, and about all you can hope to accomplish is raising their standard of living a few degrees. Down here in the cotton country you are dealing with individuals who want to rise above privation and degradation, and you soon get to where you are fighting mad about the subjection and intimidation they live under. Any one of these tenant farmers, once the fear of the landlord is taken out of his mind, will fight for his rights at the drop of a hat. That's why these peons will be dangerous people some day. They'll fight for what they want; the slum people won't fight, because they're beaten and know it. I've talked to tenant farmers who trembled like a leaf when they were talking about their landlords, but after they've lost their fear they have to be held down in order to keep them from trying to start an agricultural revolution the next day. As soon as they find out that the best way to go about changing the tenant-farming system is by educating all tenant farmers so there will be concerted action, they see right away that's a better way than going up and busting their landlord on the nose. They are holding themselves back now, but if they can't get tenant farming changed so there will be a decent living coming to them, there's no telling what will happen. The next hard pinch that comes along is going to make sharecroppers just like so many hot potatoes to handle.

MEMPHIS, TENNESSEE

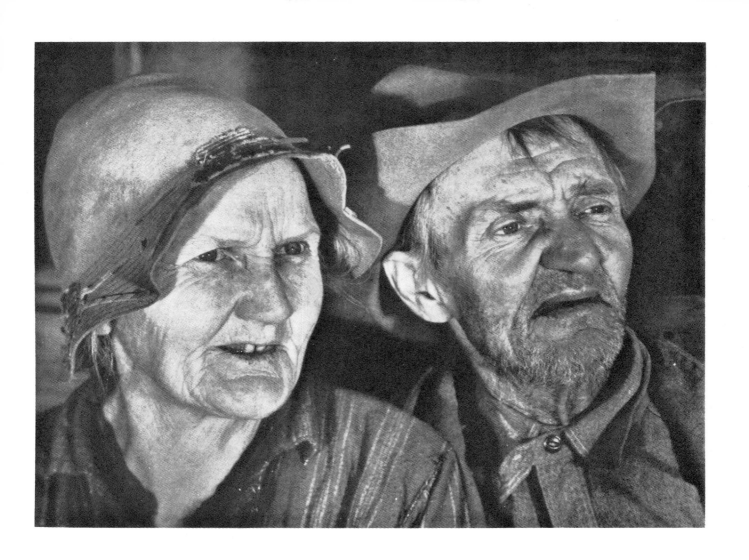

Yazoo City, Mississippi
"I think it's only right that the government ought to be run with people like us in mind."

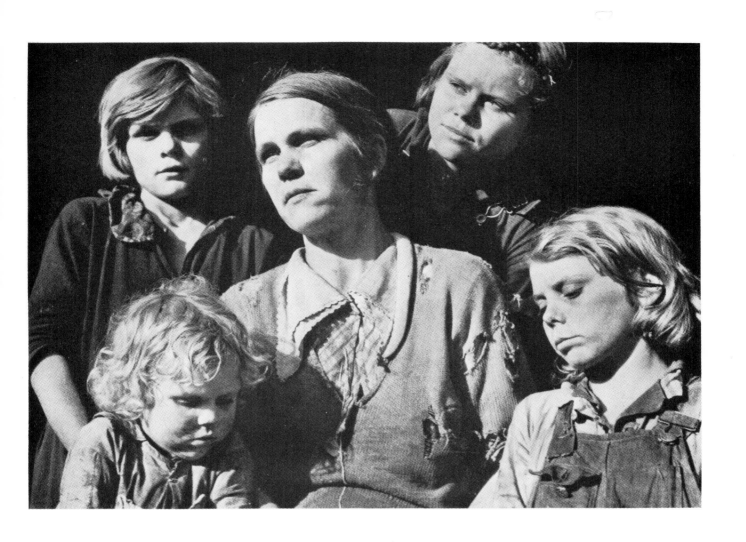

Dahlonega, Georgia

"I never see my married children any more, but I suppose they have children of their own to take care of."

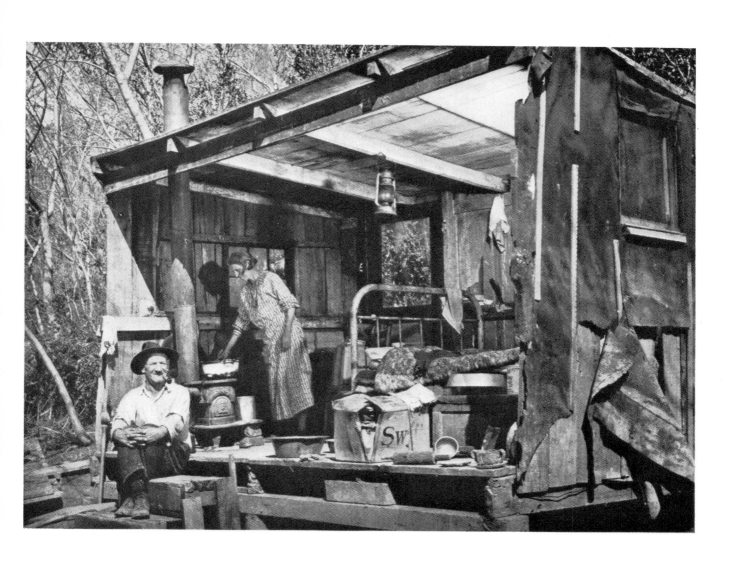

Natchez, Mississippi

"I spent ten months catching planks drifting down the river to build this house, and then the flood came along and washed the side of it off. Doggone if I don't like it better the way it is now."

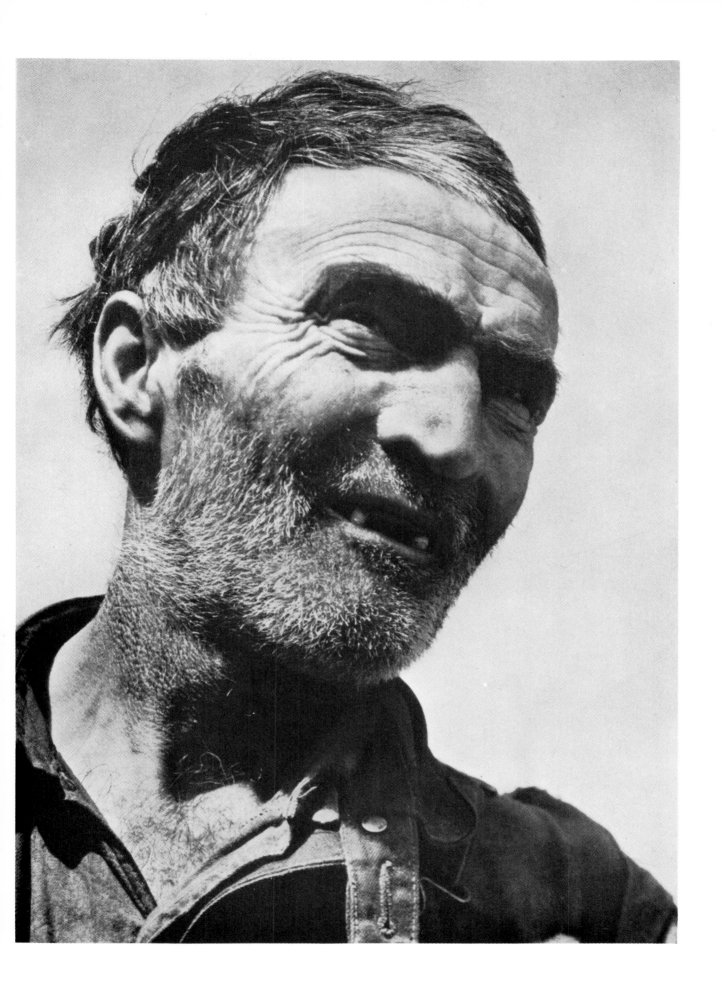

McDaniel, Georgia

"I get paid very well. A dollar a day when I'm working."

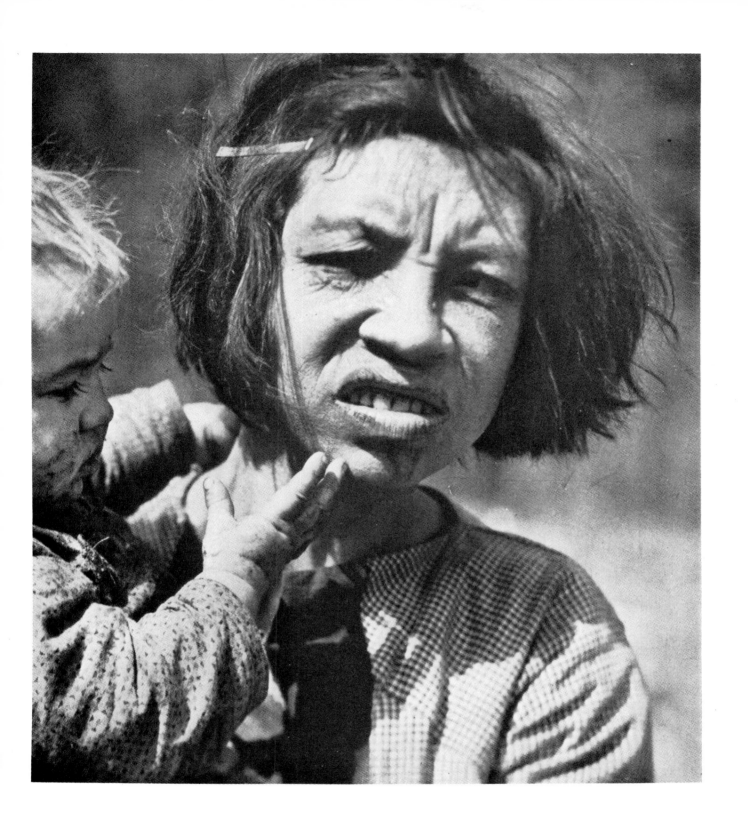

McDaniel, Georgia

"Snuff is an almighty help when your teeth ache."

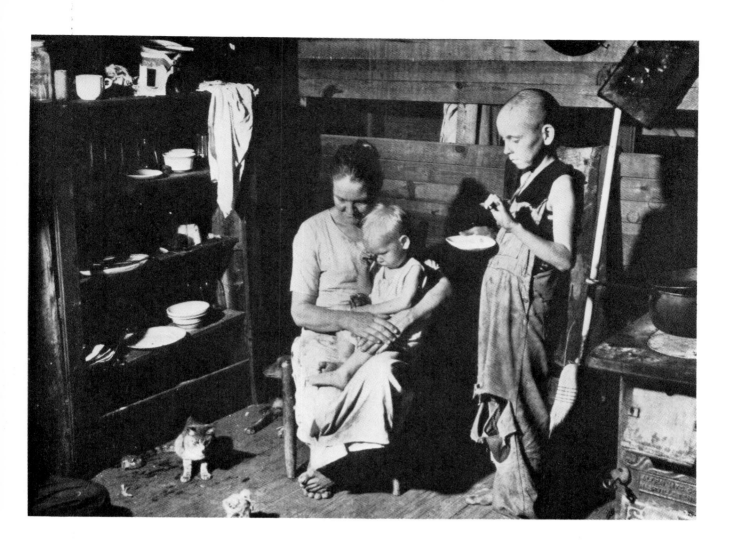

Peterson, Alabama
"I suppose there is plenty to eat somewhere if you can find it; the cat always does."

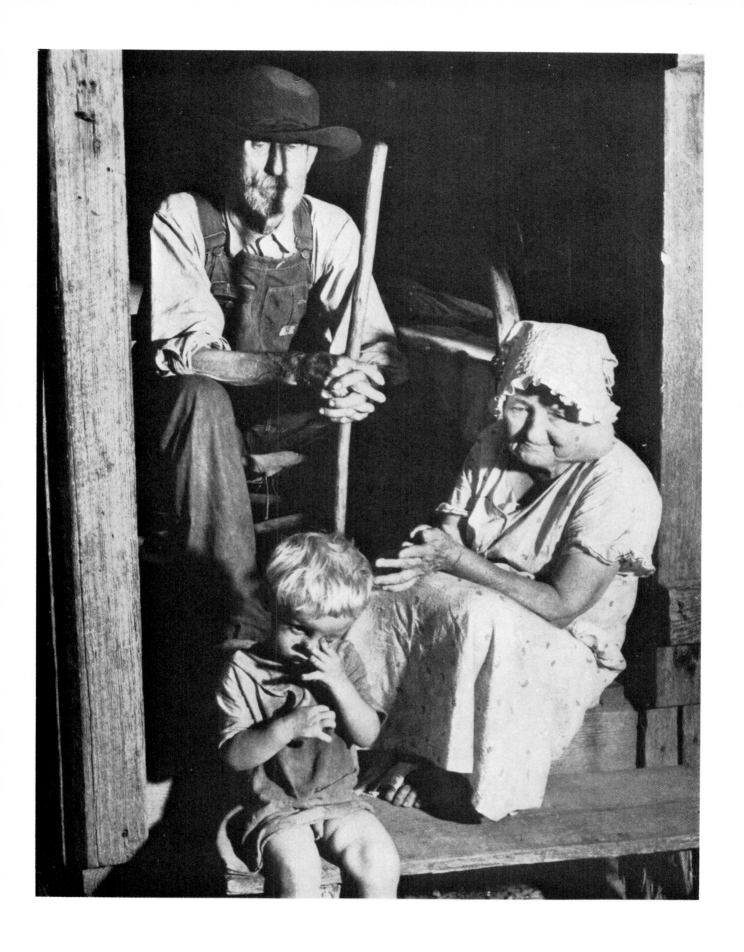

Sweetfern, Arkansas
"Poor people get passed by."

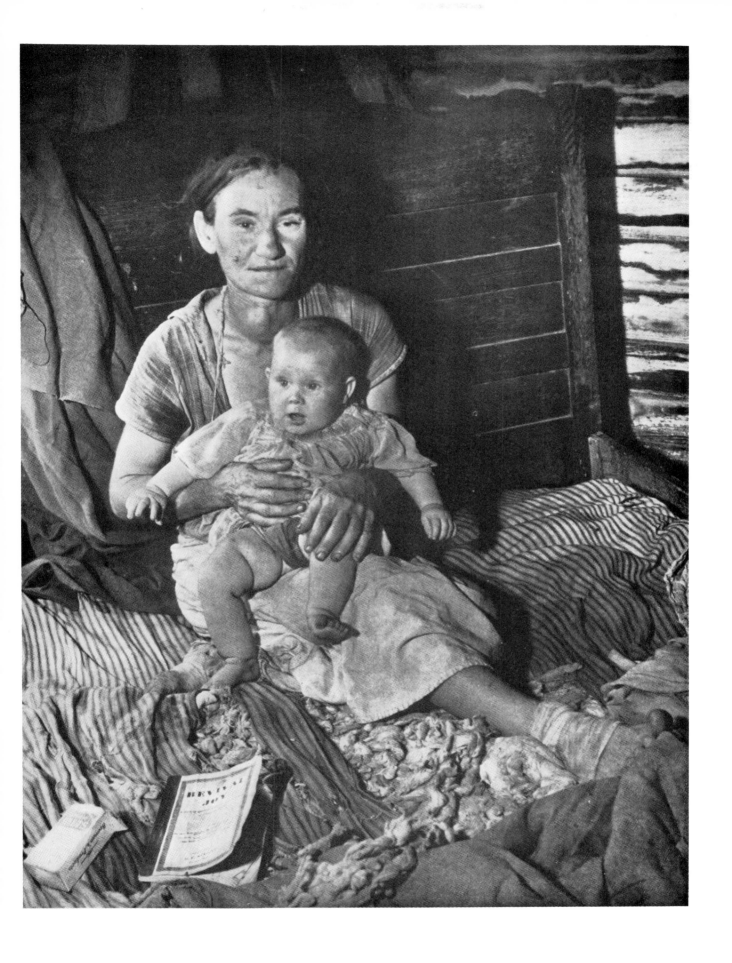

Happy Hollow, Georgia

"Sometimes I tell my husband we couldn't be worse off if we tried."

VI

Eighteen years ago I went to the bank and said I wanted to buy me a farm. I don't reckon it made any difference if I was a colored man, because they said they'd sell me this place if I thought I could pay for it. I asked them how much it would be, and they said eighteen hundred dollars on time, or eleven hundred dollars cash. I still don't know if thirty-seven acres of this hillside cotton land is worth that much, but I signed up to buy it on time. They knew I didn't have eleven hundred dollars in cash, but I didn't mind paying seven hundred dollars more than it might be worth, because I wanted to own my own land and not have to rent or sharecrop for a living. I've paid a little on it every year since then, but I don't know how much I've paid. I don't reckon I'll ever finish paying for it, because the interest keeps adding up, and I don't make much more than a living for me and my wife as it is. The land is just about wore out now, and it couldn't be worth much if I tried to sell it. If I stopped making payments, I'd lose my land and all I'd paid on it. On top of that I'd just have to turn around and rent me a place somewhere, or else sharecrop some place. Me and my wife worked hard to run our farm, but it looked like it didn't make no difference, because the land just wouldn't make enough to pay off the payments in full every year. I reckon I'm a little better off than most colored folks, though. But what I hate most is to have to farm such worthless, wore-out land.

<div align="right">RIPLEY, TENNESSEE</div>

There have been spasmodic signs of an agricultural revolution in the

cotton country in the past, and in the future these portents can be expected to be seen more frequently. Strikes during the cotton-picking season indicate that a show-down between tenant farmers and landlords is inevitable.

A lot of time has been wasted listening to the parochial schemes of political windbags who would take oath at the drop of a hat that they have, in their own words, the interest of the common people at heart. In the meantime ten million persons in the cotton country have waited patiently for a tolerable existence to be made available to them. Sooner or later they will begin to wonder whether urtication is the cure for what ails them.

There have probably been as many methods offered for the elimination of economic distress among field hands, renters, and sharecroppers as there are known cures for warts, and none of them has proved to be any more effective. Four persons out of five can be counted upon to give pat answers to a question for which no reply is yet available.

The plantation-owner usually answers the question to his own satisfaction by saying that white tenant farmers, if they are worth their salt, will acquire their own land, and that Negro tenant farmers do not need anything more than a bare living, anyway.

Politicians and ministers will sometimes agree with each other to the extent of saying that the remarkable curative properties of time will produce an equable balance between the landlord and the tenant, and that some day in the future the owner and the worker will share and share alike in the distribution of wealth.

Sociologists of one school stake their reputations on a plan for sterilization of the mentally and physically unfit among the tenant farmers, and those of another school hold to the belief that educational advantages and health instruction will suffice.

Economists, although agreeing on the fact that a need exists, find it more difficult than any other group to reach among themselves an ac-

ceptable program of action. The more radical among them insist that the feudal plantations should be broken up at any cost. The more conservative advocate helping the tenant farmer buy his own land.

The tenant farmer himself is usually willing to try anything that he thinks will help him make a living on a scale high enough to remove the association of animalism from his mind.

Tenant farmers have lived for so long a haphazard, catch-as-catch-can existence that most attempts to help them have proved to be wasted effort. Furnishing them with mules, either by outright gift or by selling to them on small payments, is not wise because mules can be sold, starved, or beaten to death. Providing land to a man not qualified to take care of land means that it will be allowed to erode, that it can be sold or traded, and that it can be exhausted of its fertility. Supplying farm machinery, by gift or sale or rent, means that in all probability the tractors and plows will not have proper attention and care, and that the life of the implements will be shortened by exposure to the weather and by abuse.

There is no evidence to show that any plan thus far advocated will in itself be sufficient to change the economic condition of the Southern tenant farmer. There is no reason to believe that any plan would succeed unless it were accompanied by re-education and supervision. There are two means of bringing about a change: one method is collective action by the tenant farmers themselves, the other method is government control of cotton farming.

Unionization of tenant farmers has been in progress for some time, principally in Arkansas and Alabama, but it has been difficult to bring together such a widely scattered mass of people under a central organization. The greatest hindrance to collective bargaining has been the fear that has been instilled in cottonfield workers by landlords for generations. For that reason the most successful attempts to organize have been in the heart of the plantation country, where the density of popu-

[165]

lation gives the tenants a feeling of safety. The isolated sharecropper in the hills is sometimes afraid to run the risk of being a union member in a region where the closest neighbor may be ten or fifteen miles away.

The landlords, no matter how sympathetically inclined at heart, will not of their own volition take steps to alleviate the tenant farmer's condition. An individual landlord will, to the best of his ability, consider that he is doing all he can, without injury to himself, to give his tenants a reasonably high standard of living. But no matter what his motives are and no matter what steps he takes he is continuing the operation of a ruinous system of agriculture. It is ruinous because the system itself is not a collective venture but one of personal profit.

The fact that the landlord operates a plantation for profit places him in the position of a business man, and business, elsewhere, has long had laws imposed upon it designed to assure the public of fair treatment. Business, other than plantation cotton farming, is conducted under restrictions that attempt to prohibit practices which inflict injury upon labor. Minimum wage laws and child labor laws were enacted to protect the worker. But a landlord employing a hundred workers enjoys special privileges that exempt him from paying a living wage, furnishing a healthful dwelling, and guaranteeing periodic settlement in money for work performed.

There will always be farm laborers. Not all tenant farmers have a desire to be the owners of land. But all men, women, and children who work on tenant farms have the right to demand adequate pay for the work performed. If the landlord refuses to pay for work done, he should either be barred from employing labor, or be forced to post a bond that would insure the payment of wages. Field hands and sharecroppers should have the same protection from unscrupulous employers that workers in steel mills and department stores receive. If the States and the Federal government refuse to provide protection to this class of citizen, tenant farmers have every right in the world to protect them-

selves against unscrupulous and untrustworthy employers. In that case, it is the duty of the States and the Federal government to inspire, promote, and protect unionization of cotton farmers in the South.

Efforts that the government makes in that direction will not prove to be sufficient until all tenant farmers are given an opportunity to earn a living. Some provision has been made for the farmer who wishes to leave the plantation and work his own crops. Rehabilitation and subsistence farms, land loans and crop loans, have appealed to men who are capable of making a living without the supervision of overseers. These are a small percentage of the tenant-farming class. Most tenant farmers are content to work as field hands and sharecroppers, providing they receive a living wage for their labor, and would much prefer not to have the responsibility of land ownership. No provision has been made for these workers, and it is on these that the hardest blow falls. They are the men and women who work for from fifty cents to a dollar a day, from three to six months a year, and who are forced to live in a dwelling detrimental to health, to wear insufficient clothing in cold weather, and to exist on an insufficient quantity and variety of food. These are the people who develop pellagra, and who use snuff to deaden the desire for food.

There is an urgent need for a government commission, provided it were invested with authoritative power, to make a study of tenant farming in the cotton country. The commission, in order to produce effective results, would be non-political in membership, and not subject to restrictions by individual senators and congressmen. Its purpose would be to study all phases of tenant farm life over a period of time long enough to familiarize itself with the needs of the tenant farm class. It would have the authority to plan for the future of cotton farming on the basis of the sociological and economic needs of the people and the land.

The commission should be composed mostly of sociologists, econo-

mists, and Southern agronomists. Its membership would include at least one sharecropper and one field hand. The tenant farmer's union would be represented. A landlord would also be a member of the commission.

It would be difficult to foresee the final result of such a study. No surmise could be undertaken until the facts of the study itself were known. Whatever the first results of the study would be, they would be enough to show how little was previously known about the tenant farming system, and that some planning is necessary in order to regenerate ten million persons who actually are, or are threatened with the possibility of, living in economic slavery in America.

Ten million persons on Southern tenant farms are living in degradation and defeat. They have been beaten and subjected. They are depleted and sterile. All has been taken away from them and they have nothing.

But they are still people, they are human beings. They have life. The older ones can be helped by charity and relief, and the remaining days they live can be made easier for them. Beyond that, there is little else anyone can do for them. They are the wasted human beings whose blood made the cotton leaves green and the blossoms red. To the cost of raising cotton add the value of human lives.

The young people still have strong bodies and the will to succeed. They can change the agricultural system that broke the bodies and wills of their parents. They can stand up without fear and demand that they be paid adequately for their labor. They can look their landlords squarely in the eyes and say they will not be intimidated by threats. They have the courage to refuse to work for a landlord who cheats them out of their pay and uses dishonest means to take their cotton away from them. The young people, the boys and girls, the young men and women twenty, twenty-five, and thirty years old, have the power in themselves to fight against any system that attempts to break their bodies and spirits as it did their parents'.

The youth of the South can succeed where their mothers and fathers failed if they will refuse to raise another man's cotton while hungry and in rags. With hope and a dream before them, they can change a hell into a living paradise. When fear has been banished, and self-respect restored, America will wake up to find that it has a new region to take pride in.

This land never did look like cotton land to me, but I planted cotton in it as fast as the years came around and nothing much ever came of it. Sometimes I'd make two or three bales on the eight acres, and share it with the landlord. About seven or eight years ago him and me both got fed up on planting cotton here and not getting much more than the seed back out of it, and so I decided on planting it in corn. The doggone corn didn't amount to much either. About then I got something in my blood. I got to feeling like the land just wasn't no good at all for nothing. I couldn't do nothing with it, and I felt tired out all the time. The landlord said he'd be satisfied to get two wagon-loads of corn a year for rent, instead of sharing, and so the past few years I don't do much about it except to plant just about enough corn to get two loads of corn to pay the rent with. I figure it's worth that much to me to live in a house. It don't matter one way or another much now about making a living. I just don't have no feeling about it at all. When something got in my blood the years back, I sort of lost interest in doing much of anything. Last year my wife went out and got herself a job with the government, and now she's making twenty-one dollars a month working at the sewing-house. That just about takes care of everything. The one boy don't seem old enough yet to eat much, and what there is to eat seems just about right to fit the bellies we've got. But if I didn't feel so strung out, I guess I'd be up and doing like I was when I started farming eighteen years ago. I blame it all on the land. It just wasn't no good for cotton or corn, and I'm glad I found out about it before I wore myself all to pieces tussling with it.

<div align="right">LIBERTY, MISSISSIPPI</div>

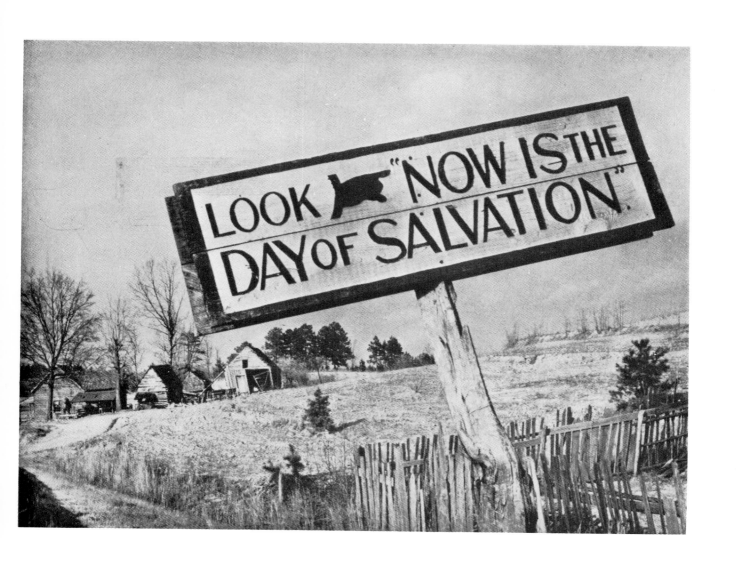

Hull, Georgia

"Sometimes I feel like I've lived on this place since the world began. Maybe I'll be here when everybody else has gone to heaven."

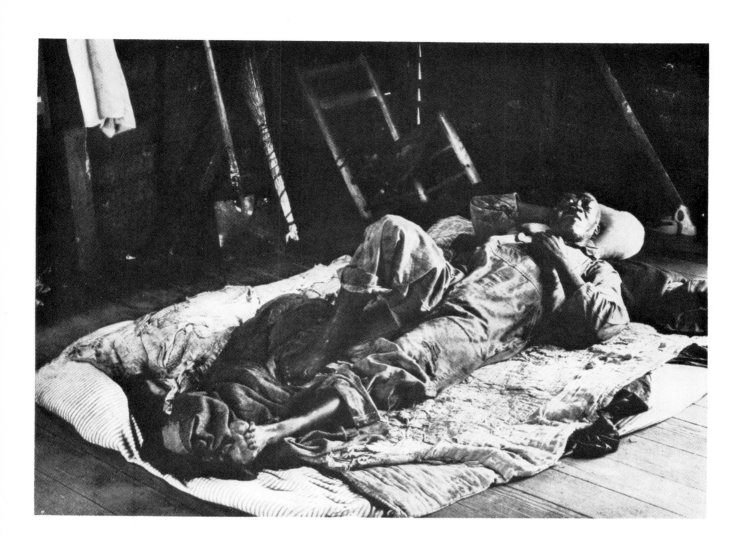

Matthews, Georgia

"When the time comes to die, it don't make much difference if you is poor, you just have a feeling you're sorry to be leaving."

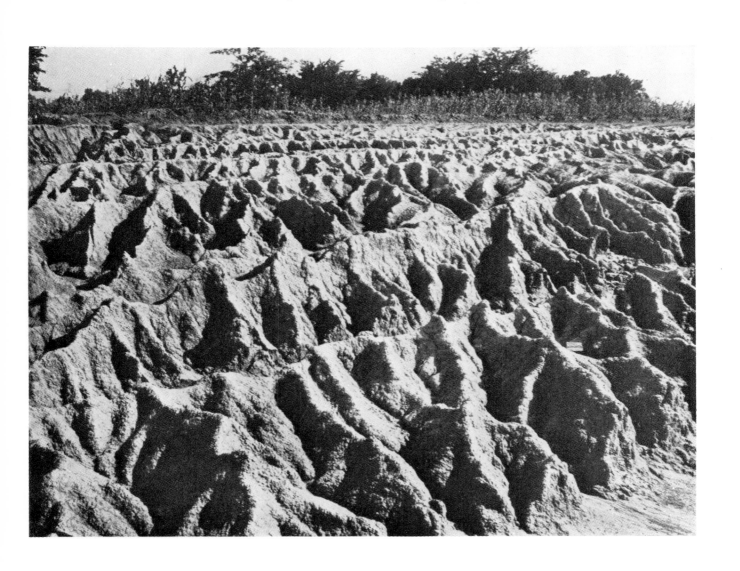

Brownsville, Tennessee

"It looks like God can't trust people to take care of the earth any more."

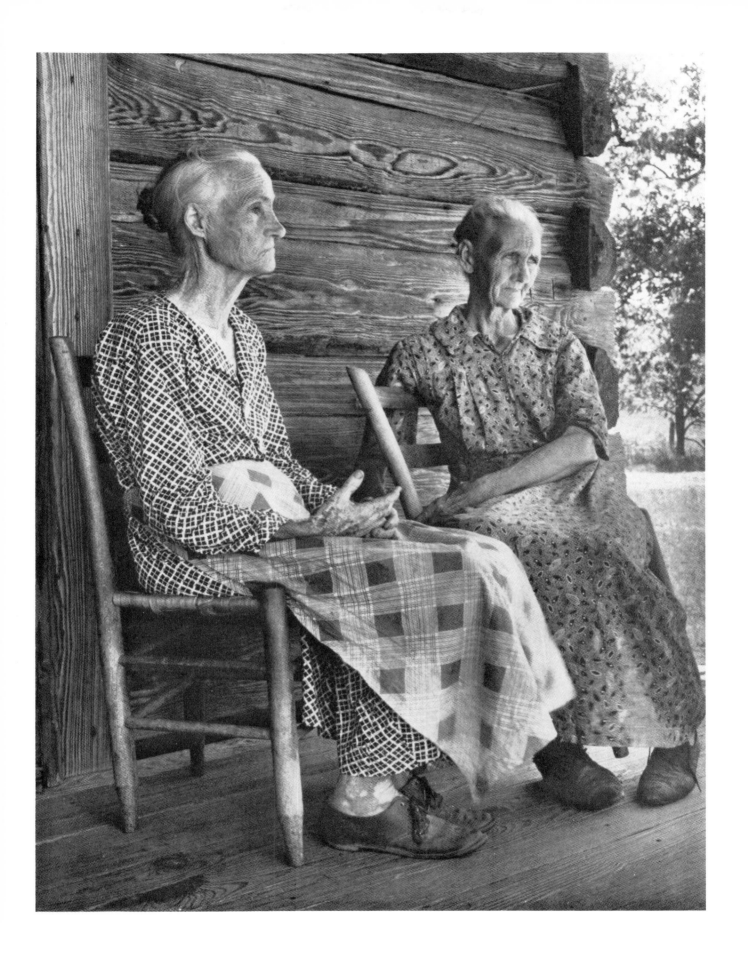

Lansdale, Arkansas
"There comes a time when there's nothing to do except just sit."

Rose Bud, Arkansas
"I remember when that automobile was a mighty pretty thing to ride around in."

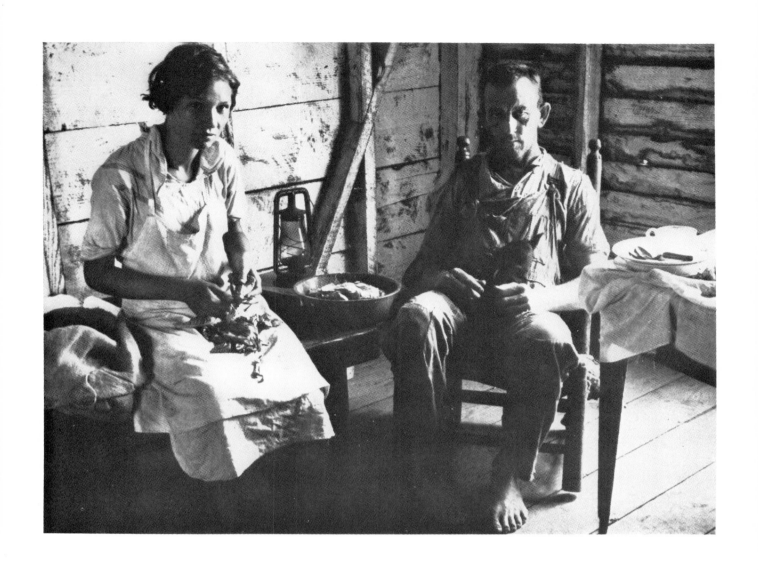

Locket, Georgia
"There's probably no man alive who likes to see the sun rise as much as I do, and hates so much to see it set."

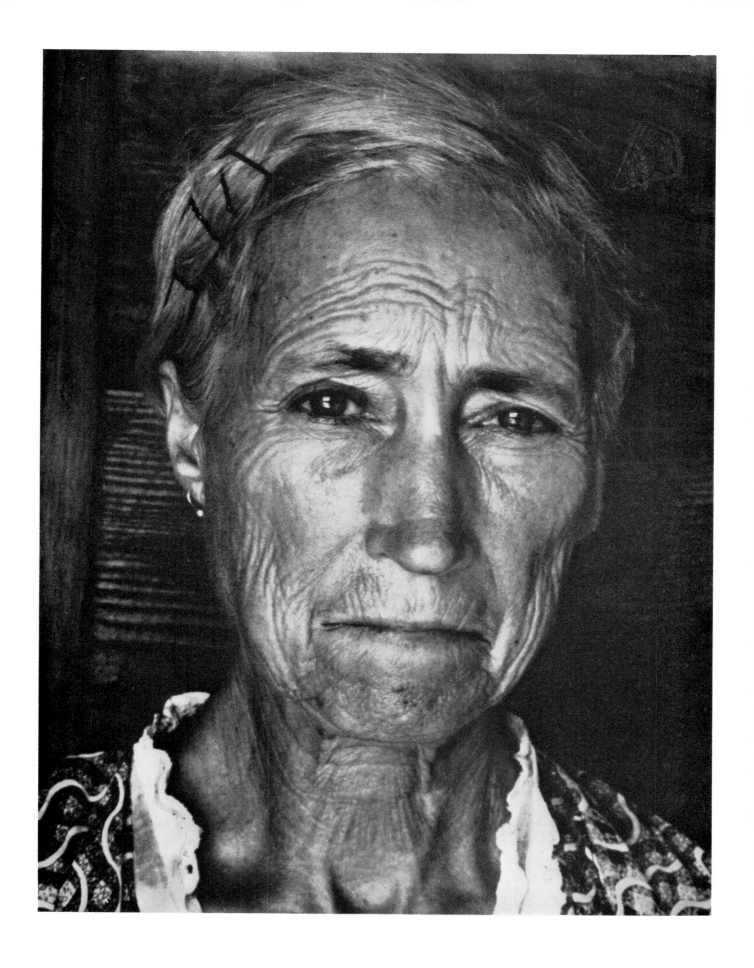

Locket, Georgia
"I've done the best I knew how all my life, but it didn't amount to much in the end."

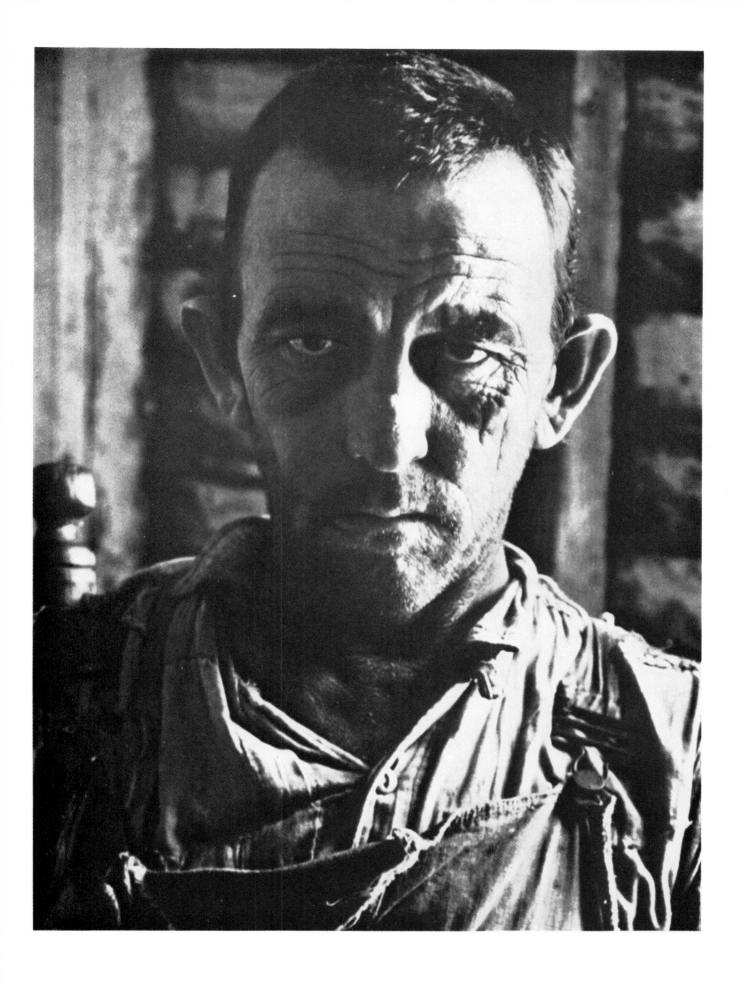

Locket, Georgia
"It ain't hardly worth the trouble to go on living."

WHEN we first discussed plans for *You Have Seen Their Faces,* the first thought was of lighting. Electricity would be unavailable in many places we planned to photograph. This made flash bulbs operated from batteries a necessity for photographing interiors under all conditions. Although I was reluctant to fall back on flash bulbs at the beginning of our trip, by the end of our journey I was devoted to them.

Flash bulbs provide the best means I know, under poor light conditions, of letting your subject talk away until just that expression which you wish to capture crosses his face. Sometimes I would set up the camera in a corner of the room, sit some distance away from it with a remote control in my hand, and watch our people while Mr. Caldwell talked with them. It might be an hour before their faces or gestures gave us what we were trying to express, but the instant it occurred the scene was imprisoned on a sheet of film before they knew what had happened.

[187]

Wishing to avoid the flat lighting that results from the usual synchronizing device in which the reflector is attached directly to the camera, I had an arrangement built with extensions. With this could be used a two-way or three-way plug from the synchronizer, or a spider box if more outlets were needed, with cords plugged in, fitted with reflectors of the convenient clamp-on type. Thus I could compose with several sources of light.

Most of the interiors were taken with Panchro-press film; some with Super-Sensitive Panchromatic, which is also quite satisfactory with flashes. For outside work Super-Sensitive Panchromatic was employed throughout.

We carried five cameras, using most frequently a small view camera, the Linhof. It is a flexible instrument, with tilting and rising front and tilting and revolving back, size 3¼" x 4¼". It was equipped with a battery of lenses in varying focal lengths from wide angle to telephoto. Many of the houses we worked in were so small that I was grateful for the 9 cm. Angulon, even though a wide-angle lens is something I seldom use because of the danger of distortion. The faces we found everywhere were so interesting that frequent use was made of the Schneider Tele-Xenar 27 cm., as the long-focus lens gives excellent drawing for portraits. For the bulk of the work I depended on Zeiss Tessar lenses, using mainly 13.5 cm., 15 cm., and 18 cm., in F/4.5. Each lens had its own separate magnet device connecting with the synchronizer, adjusted precisely for each shutter.

Supplementing the Linhof, I carried a Soho, a reflex type size 2¼" x 3¼". It is built in England, and has a tilting and twisting front, an accessory to the reflex not incorporated in our American-built cameras which I consider so essential for accurate focusing that I cannot see why reflex models, except those with a very small film size, should be built without it. Here again I carried lenses of varying focal lengths to give a choice of perspective, using chiefly a Cooke Anastigmat Series X,

6⅜", F/2.5, and a Zeiss Tessar, 13.5 cm., F/3.5. The Soho was used on a good deal of the outside work. Pictures showing people working in the fields were taken with this camera, the plowboy with an E 22 (red-yellow) filter. The flexible frontboard of this camera is well adapted for following action, as the amount of stopping down necessary to keep depth of focus is reduced to a minimum, making it possible to use maximum speed.

A Contax Model 2, with Sonnar F/1.5, 5 cm. lens, went along as it does on all trips, for a miniature camera will take pictures where nothing else will. The kit included an old 3¼" x 4¼" Revolving-Back Auto Graflex, with 7" Kodak Anastigmat F/4.5 lens, which always travels with me. No matter how careful I try to be, I have yet to take a journey without accidents to equipment. A camera will topple over; a shutter will jam; minor disasters will befall my favorite tools when I am out of reach of repairs. The Graflex is a comforting old standby when more delicate mechanisms fail.

My fifth and last camera, the 1⅝" x 2¼" Super Ikonta A, with Zeiss Tessar F/3.5 lens, was pressed into service on the churches. It is a convenient little instrument to use synchronized with a flash gun, for it has some of the facile advantages of the miniature without necessitating quite the tiny film size. Elaborate setting up of lights and batteries would have been impossible when following shouting, gesticulating ministers about their churches. It was hard enough to get close to them with a camera at all.

We decided to slip lightly equipped into the Holiness church after the sermon was started, Mr. Caldwell with his pockets full of bulbs, and I with Ikonta and synchronizer attached. I believe the only reason we were successful was because the minister had never had such a situation to meet before. Photographers walking into the middle of a sermon and shooting off flash bulbs were something he had never had to contend with.

[189]

As the service progressed, the excitement grew so high that we were completely forgotten. Mr. Caldwell changed bulbs as fast as I could make shots. The women waving hymn books were rushing up and down the floor in such a state of hysteria that several times I was nearly knocked over and the camera almost jarred out of my hands. The small camera served well here because setting up and focusing anything larger would have been impossible.

Even the small camera failed us with the chain gang. When the plump captain, pictured in these pages, blocked all attempts at photography, we drove down the road and planned the only possible course of action. Mr. Caldwell would drive the car back through the gang slowly while I shot as fast as I could through the window. When the captain shouted that he would shoot off our tires, even that plan had to be abandoned, not too regretfully on my part, because photographs caught on the fly may serve as a record but they allow no chance for careful composition.

After considerable research among local politicians, we were successful at last in getting a letter from the Commissioner giving us permission to take photographs. Confidently we hunted up our chain gang and handed our authoritative paper to the guard, only to find that he could not read.

It was up to us to read and reread the document with such emphasis, such dramatic eloquence, that he could not do otherwise than let us bring out cameras and take our pictures.